I'M HERE

ATSUSHI WATANABE

渡辺 篤

アイムヒア

共感の不可能性の高い存在、それはつまり「他者」のことである。

姿が見えず、声も聞こえない不在者。

それは当然、共感の不可能性が高いと言える。

彼ら彼女らは、一体何を考え、なぜそこに留まるのか。

この国には、孤立を続ける「ひきこもり」と呼ばれる者たちが110万

人以上※居るらしい。

ひきこもりとはつまり、より「他者らしい他者」なのだろう。

ひきこもりは自ら望んでそれを体現しているのだろうか。

生きづらさを再生産し続け、社会の隅々までをも覆い尽くしてしまっ

たのは他でもない私たちだ。

既に私たちのうちの誰かは、もうここから居なくなってしまった。

私たち社会が彼ら彼女らの居場所を奪ってきたのかも知れない。

私も過去にひきこもりだった時期がある。
けれども、別のひきこもりの当事者性を代弁はできないのだと知った。

私たちはいくら望めども他者に共感することができない。
共感は幻想だ。
理解の出来なさを再出発点とし、
そこに必要なのは「共感したつもり」ではない。

人を理解出来ずに傷つけもし、
けれど人に寄り添う生き物として、
他者との関係の再構築のために、
これから「対話」が必要だ。

渡辺　篤

※　内閣府が2019年に発表した実態調査では、40〜64歳までのひきこもりの人数は推計約61万3千人
　　居るとされた。40歳未満の推計54万1千人に加えた場合、115万人ほどと算出できる。

There are those who have the strong impossibility of empathy; namely "others."
The absent, who cannot be seen and whose voices cannot be heard, naturally suggest the likelihood of lack of empathy.
What on earth are these men and women thinking and why are they staying there?

In this country, Japan, it is estimated that more than 1.1 million people are des-ignated as *hikikomori*, living in continuous isolation*.
The number can possibly suggest that the *hikikomori* are even more "others" than "the others" to us, but I wonder whether or not they are experiencing the isolation by their choice as they seem to.

Undoubtedly, it was us who have acutely infiltrated the stiffness into the society while continuing to reproduce someone's unbearableness of living.
Some people in our society are even no longer here, having already opted to with-draw from society.
In other words, they might already have been deprived of their places to be by the society.

I myself was a *hikikomori* in the past.
Yet, I noticed that I have no voice for those who have the same experience as I did.
We are unable to empathize with others no matter how much we hope to do so.
Empathy is only illusion.

What we need is not the intention of empathy but the reconsideration of our incapacity that we can never understand others.
When we hurt someone as a result of the incapacity, rebuilding the relationship through dialogue is inevita-ble because we are always standing close to others.

Atsushi Watanabe

* The Japanese term *hikikomori* literally translates as "pulling inward or being confined." It refers to a societal phenomenon in Japan of acute social withdrawal, designating reclusive adolescents or adults who shun all social contact and seek extreme levels of self-isolation. A survey conducted by the Cabinet Office in Japan in 2019 estimated that there were 613,000 *hikikomori* between the ages of forty and sixty-four. If one adds the estimated 541,000 *hikikomori* under the age of forty, one comes to a figure of about 1.15 million.

THE DAY OF LIBERATION

Suspended Room, Activated House

再起の日 止まった部屋 動き出した家

東日本大震災の直前まで私は深刻なひきこもりだった。10年患った鬱、婚約者の裏切り、若き芸術家ゆえの将来の不安、参加していた市民運動からの排除。複数の傷や居場所の喪失が原因だった。社会へのあてつけに未来を諦め、寝たきりで過ごした。今思うと精神的な意味での自殺ともいえる。意思の通い合えない家族とは顔も合わせたくなくて、尿はペットボトルに溜めていた。介入してこない母、迷惑者を家から排除するため措置入院の計画をし始めた父。だんだんと一生の覚悟を背負いながらひきこもり続けていたものの、7ヶ月経ったある日、閃きと共にその終わりは訪れた。「父にこの先の人生を支配されたくない。気付いたら自分より疲弊してしまっている母を守らなければ!」天井の染みを見つめ続け、将来を諦め続けていたのに、結局シンプルで前向きな答えに戻っていた。

最後の日、髪も髭も伸び放題のセルフポートレートと、荒廃した部屋を撮影した。「そうだ。きっと膨大な時間を費やし、私はこの写真を撮るために役作りをしていたのだ!」永い心身のとらわれの時間をアートで価値転換させた。再び生きる勇気が湧きだした。

東北の震災下、ひきこもりの人たちも大勢、家と共に流されたそうだ。また一方ではそれを機に、自分より傷ついた者の存在を知り、部屋から出て福祉の仕事などに就いた者も多くいたという。ひきこもりは命の問題でもあるのだ。

私はこの時の個展開催に向け、ブログを通じて全国のひきこもりに呼びかけ、部屋の写真を募集し展示した。会場にはアートファンだけでなく、思いもよらず、写真を送ってくれたひきこもりも複数訪れた。

展示室中央には、津波に流されゆく家を表すコンクリートの小屋を置いた。当事者性に再度身を浸すこと、また、仏教修行的要素の可能性を込め、会期中、中に一週間ひきこもった。図らずも、心身の限界に触れるパフォーマンスとなった。

Up until just before the Great East Japan Earthquake, I was a serious *hikikomori*. It was due to my feeling as if I had lost my place in the world, along with the many wounds left by ten years of depression, my fiancée's betrayal, worries about my future as a young artist, and my rejection by social movements I had been a part of. I gave up on my future to spite society, and spent my days bedridden. Thinking back on it, I feel like it could be called a kind of suicide in a mental sense. Not wanting to even come face to face with family members I couldn't relate to, I collected my urine in plastic bottles.

My mother did not intervene, and my father saw me as a nuisance to be removed, and to that end began planning to have me committed to a mental hospital. I continued to live as a *hikikomori*, gradually coming to terms with the idea that I might be that way for the rest of my life. However, one day after seven months had passed, an end suddenly appeared in sight along with a flash of inspiration. I realized that I didn't want to dominate my father's life going forward, that I had to protect my mother who, when I took a step back and looked at things, was rapidly growing far more exhausted than I was. I had spent so long staring at the stains on the ceiling and abandoning all dreams for my future; but in the end, I came back to that simple, optimistic answer to my problems.

On my last day as a *hikikomori*, I took a portrait of myself, with hair and a beard that had been left to grow wild, as well as photographs of my room, which was in ruins. It dawned on me that I had wasted an enormous amount of time playing this role solely for the purpose of taking these photos. I had converted my long period of mental and physical imprisonment into artistic value. Once again the courage to live sprang up inside me.

During the Tohoku disaster, there were apparently many *hikikomori* who were swept away with their homes. On the other hand, I've heard that for many others it was an opportunity to realize that there were people who were hurting far worse than they were, prompting them to leave their rooms and become involved in social welfare work and the like. Being a *hikikomori* can also be a matter of life and death.

In preparation for my recent solo exhibit, I published a blog entry calling the nation's *hikikomori* to send me pictures of their rooms to be exhibited. And at the event, I was surprised to see the attendance of not just art-goers, but also many of the *hikikomori* who had sent me their pictures.

In the middle of the exhibition room, I placed a concrete shed intended to represent the homes that were swept away by the tsunami. And in order to once more put myself in the shoes of a *hikikomori*, and explore the possibilities for Buddhist training it afforded, I spent a week within the shed during the exhibition. This performance unexpectedly ended up pushing me to my limits both physically and mentally.

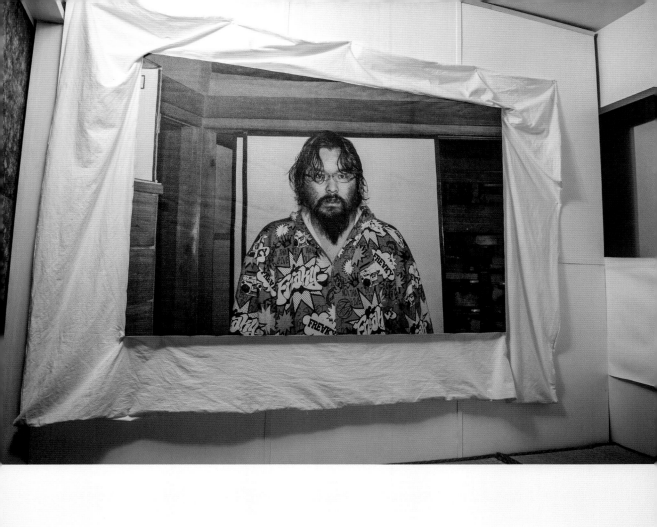
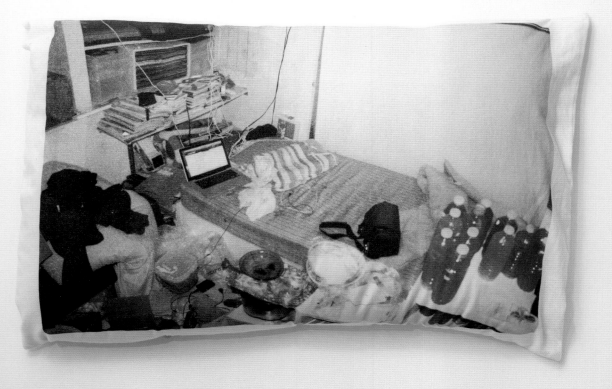

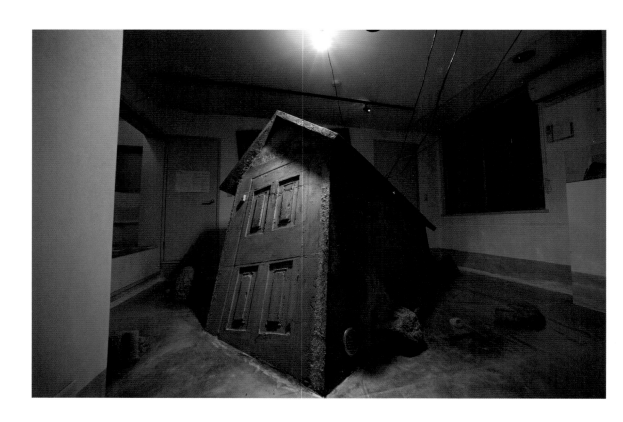

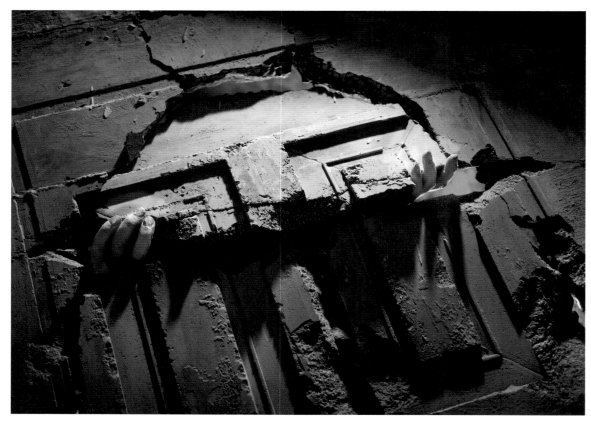

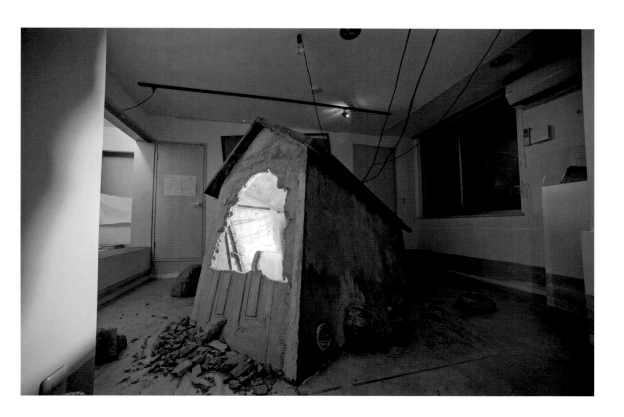

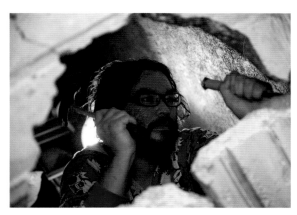

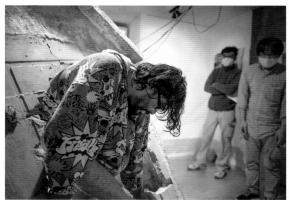

《止まった部屋 動き出した家》
2014年｜インスタレーション、パフォーマンス｜家型構造物（セメント、木材、イ
ンターホン、センサー、ライト、通気口、電源コード、布団、食料、水など）、半鏡
面シート、石群
会場風景：個展「止まった部屋 動き出した家」（NANJO HOUSE、東京、2014年）

Suspended Room, Activated House
2014 | Installation, performance | house type structure (cement, wood,
intercom, sensor, light, vent, power cord, futon, food, water etc.), semi-
specular sheet, stone group
Installation view: Solo exhibition "Suspended Room, Activated House"
(NANJO HOUSE, Tokyo, 2014)

CROSSING THE SCARS

"Tell me your emotional scars" project

<div dir="vertical">

傷が繋がる

プロジェクト「あなたの傷を教えて下さい。」

</div>

自分独自の事情をきっかけとした傷を持ってして、多くの人はひきこもったり自殺をしてしまったりするのだと思う。社会には多くの傷が生まれ続け、この世の人の数だけ傷の事情がある（日本には約110万人のひきこもりと、年間約3万人の自殺者がいるという）。今傷ついていないという"自称強い人"も、老いて死ぬまでの間に必ず一度は弱り、そして傷つくだろう。

強者の論理はいつでも容易く聴くことが出来る。大きな声は耳をふさいでも届いてくる。そうではなくて、普段なかなか聴こえないボリュームの、か細き声を聴きたい。その聴力を持ち備えるきっかけとなる装置を作りたい。本音を言えば、弱い自分が見殺しにされない社会を作るためでもあると思う。"自称強い人たち"が基準を作る社会は、住み心地悪そうだ。

私はウェブサイトを通じて、様々な人たちの心の傷の経験についてのストーリーを募集するプロジェクトを始めた。集まった投稿文のうち幾つかをピックアップし、それぞれをコンクリートの板に書いた後、ハンマーで一旦割り、さらにそれを陶芸の伝統的な修復技法「金継ぎ」を応用して、傷（ひび割れや欠損部分）を金色に輝かせながら再生させている。東日本大震災の直前まで続いた自身の深刻なひきこもり経験をテーマとした作品制作をきっかけに、傷の昇華やとらわれ意識の克服についても提案をするこのアートプロジェクトは、2017年現在、外国語圏での展開も試みている。

この時の展覧会では、会場でも傷についての文章を直筆で投函できるようにポストを設置した。多くの投函がなされ、そのうち幾つかを会期中に作品化した。

I think that many people withdraw from the world or take their lives due to wounds born of their own personal circumstances. These wounds continue to appear in great numbers within society, and there are as many different reasons behind them as there are people in the world (one theory states that there are about 1.1 million *hikikomori* in Japan, and that around 30,000 people commit suicide per year). Even self-proclaimed "strong people"–which is to say those who are yet to bear such wounds–will certainly encounter at least one moment before they grow old and die when they crumble and get hurt.

It's never very hard to hear the logic of those who are strong. A loud voice will reach you even if you cover your ears. Instead, I'd like to listen to all the delicate voices that are at a volume that is often hard to hear; I wish to make pieces of art that function as a means for people to develop that kind of hearing. Deep down inside, I think it's probably also born out of a desire to create a society that won't leave me to die because I'm weak. A society where self-proclaimed "strong people" set the standards does not strike me as a very comfortable place to live.

I began a project via my website to collect stories about various peoples' experiences with emotional scars. I picked out several of the submissions, and after writing each one on a concrete slab, I split it with a hammer, and made use of a traditional ceramic repair technique called *kintsugi** to make the wounds (the cracks and damage in the concrete) come back to life shining like gold.

As of now (2017), I am endeavoring to expand this art project–which deals with the sublimation of my wounds and the reclamation of my imprisoned consciousness through the creation of art based on my experiences as a severe *hikikomori* leading up to the Tohoku earthquake and tsunami–to countries speaking other languages.

At the recent exhibition, I also installed a postbox at the venue, so that people would be able to submit accounts of their own emotional wounds in their own writing. I received many submissions, and adapted several of them into new pieces during the exhibition.

*Kintsugi: A traditional method of repairing pottery by using lacquer to mend broken or chipped pieces, and decorating the mended portions with gold. The cracked work does not return to its original state, but the scars, cracks, fissures, and chips that are usually seen as a sign of deterioration or loss of value are given life to hold a different value, and dazzle in their new state. This technique is also called kintsukuroi, or gold mending.

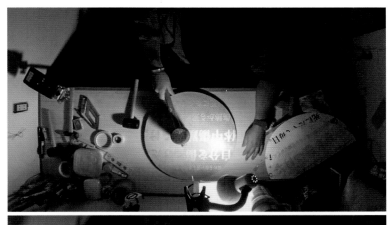

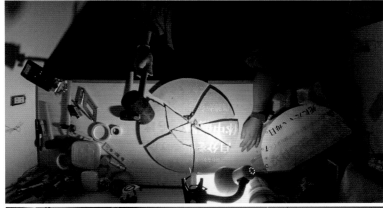

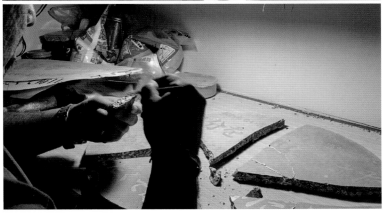

《プロジェクト「あなたの傷を教えて下さい。」》
2016年〜｜コンクリートに金継ぎ、塗料

"Tell me your emotional scars" project
2016−｜Kintsugi to concrete, paint
Courtesy of "Koganecho Bazaar 2016"

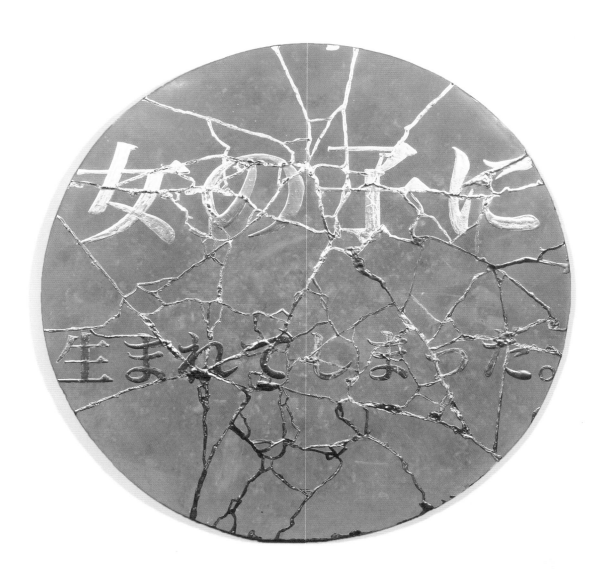

女の子に

生まれてきてしまった。

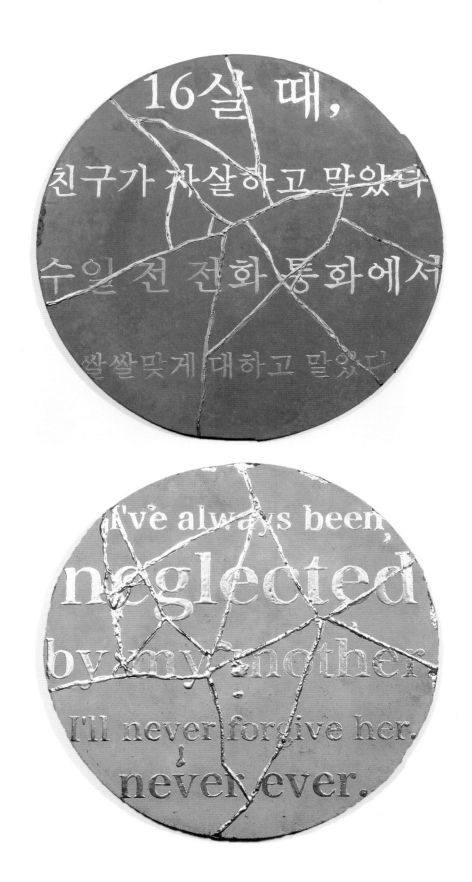

16살 때,

친구가 자살하고 말았다

수일 전 전화통화에서

쌀쌀맞게 대하고 말았다

I've always been,

neglected

by my mother.

I'll never forgive her.

never ever.

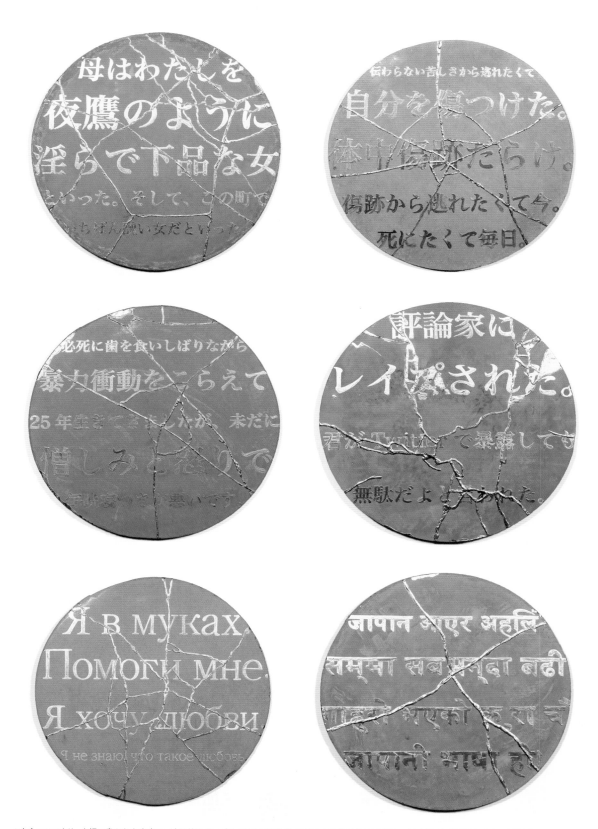

これらのコンクリート板に書かれた文章は、渡辺篤のウェブサイトでの募集企画「あなたの傷を教えて下さい。」に対して、投稿されたものを使用している。
一部、作者のテキストによる作品。

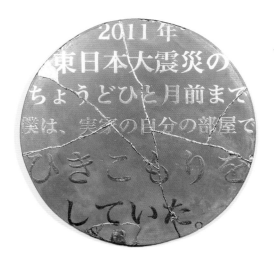

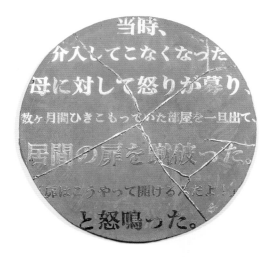

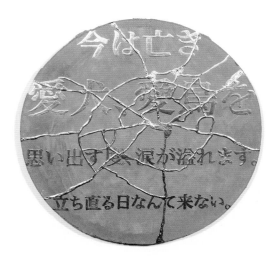

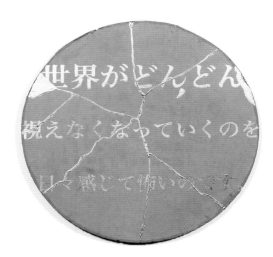

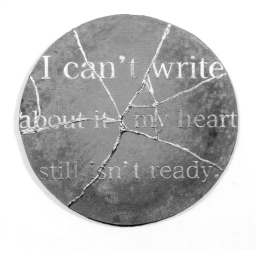

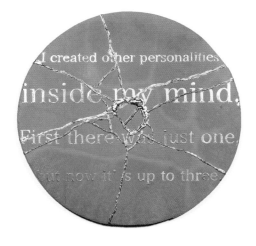

The texts written on these concrete slabs are from submissions to the "Tell me your emotional scars" project on Watanabe's website. Some are based on texts from Watanabe.

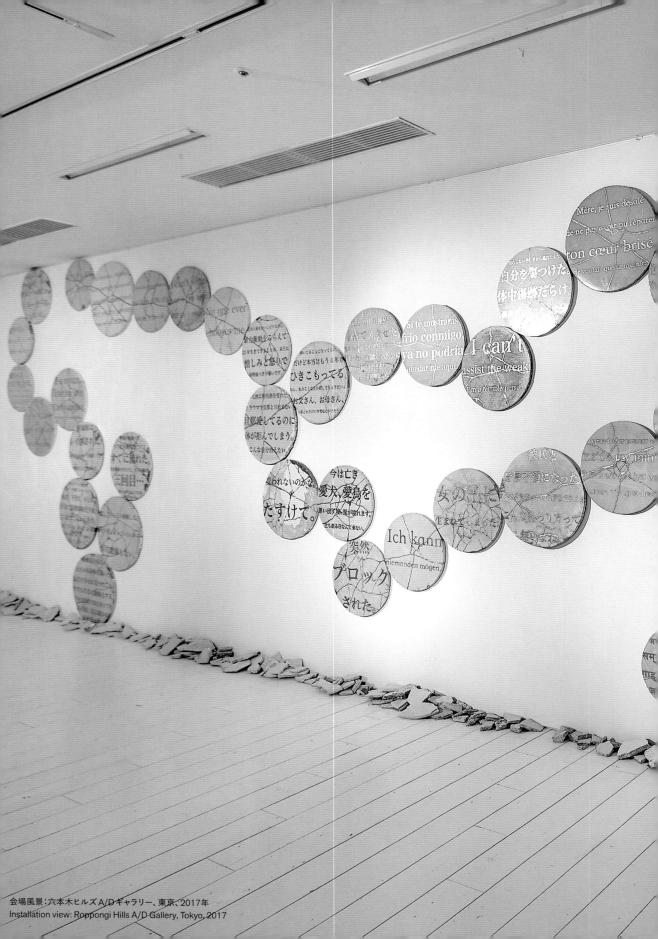

会場風景：六本木ヒルズ A/D ギャラリー、東京、2017年
Installation view: Roppongi Hills A/D Gallery, Tokyo, 2017

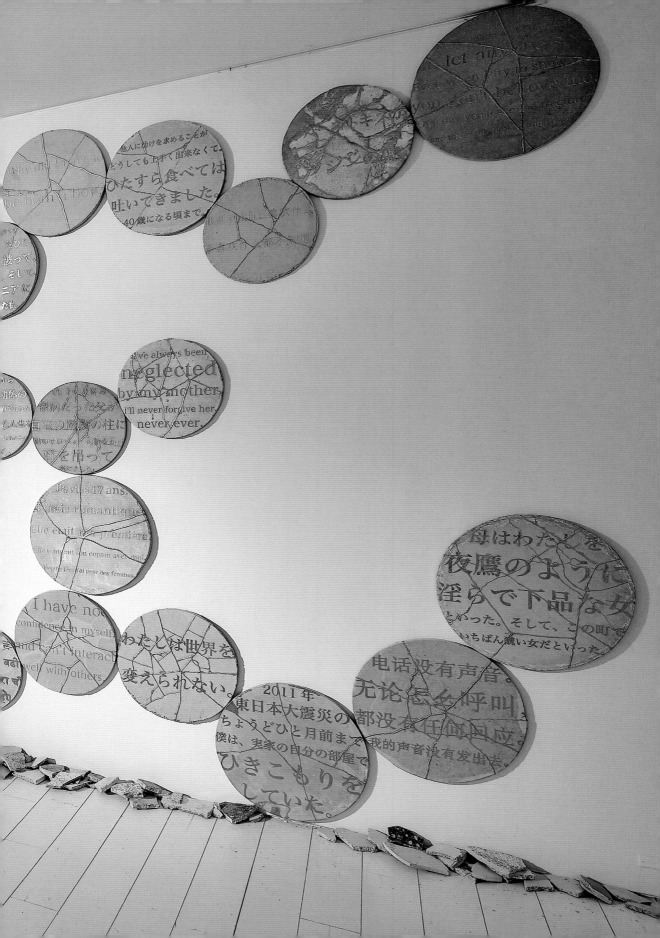

OBSERVATION BEYOND THE WALLS

I'm here project

壁の向こうへのまなざし　アイムヒア　プロジェクト

写真集『I'm here project』は、日本をはじめとする多くの場所で深刻な社会問題となっている孤立の在り方「ひきこもり」や、それにまつわる問題に対し、新たな「当事者発信」の形を模索し、当事者の尊重と社会への周知や問いを提示するアートワークである。2018年、ひきこもり当事者自らが撮影した部屋の写真を募集した※1。結果、約40名から合計約160枚※2が寄せられた。これらは本来見ることはできない閉ざされた空間の貴重な写真だ。

また本企画は、歴史的にマスメディアやアートがその権力性を用いて、困窮した当事者や社会的弱者を搾取的に取り扱ってきた動向※3を、当事者表現による逆照射によって批判する構図も取っている。企画主催者である私自身、過去に足掛け3年間の深刻なひきこもりを経験した元当事者である。ひきこもってしまった永い時間が無駄なものだったとするならば、それを引き受けて再出発していくこともまたとても辛いことだ。けれど、今ここに居る自分の姿や部屋のあり様を撮影する事で、経てしまった永い時間を「写真作品に必要な制作期間」だったという事に意味を変換出来るのではないだろうか。 そう認識を切り替え、のちに美術家として社会復帰を果たした。人生における心の傷や困窮の時間もまたクリエイティブな価値にする事はきっと可能だ。アイムヒア プロジェクトは、孤立した不可視の存在やその声を無い事にはさせない為、彼ら彼女たちの表現に伴走する。

※1. 写真投稿者全ての個人情報を保護し、写真の匿名性を守る事、本人以外からの投稿を受け付けない事、謝礼を払うことなど、極力丁寧な規約の提示や合意形成を心がけた。
※2. 一部は2014年に実施した同様企画のものを含む。
※3. テレビの特集番組などは、ひきこもり当事者の部屋の扉を蹴破って押し入り、説教をしたり施設に軟禁するなどする業者を賛美し、当事者を悪しきもののように報道してきてしまった歴史があり、近年支援者や当事者らによって批判されている（参考：『テレ朝「TVタックル」を精神科医らが批判、暴力的手法で「ひきこもり当事者」を連れ出す映像を放送』）。また、現代アートのジャンルに限っても国際的に活躍する写真家が元モデルによって現場での搾取的事情が告発されるなどした（参考：『その知識、本当に正しいですか?』| KaoRi.）。

The *I'm Here Project* photo book is an artwork produced by a project led by contemporary artist Atsushi Watanabe. The piece seeks to investigate the deep social problem of the isolated form of existence known as *hikikomori*,[1] in a new form that allows self-expression and agency to the subjects themselves, while respecting the subjects, as well as raising social awareness of the issue, and interrogating them into society.

For three months beginning Summer 2018, the project solicited photographs of rooms taken by *hikikomori*, these were found mainly online.[2] The result was that they gathered around 160 photographs[3] from roughly 40 participants. These photographs are valuable windows for us into spaces that we usyally can not see. The project worked with a camera operator and a designer to edit and produce this album.

Watanabe is a former *hikikomori*, in the past, he experienced a roughly three year period of intense isolation. Having been extremely open to discussing his own experiences, he has moved on to gathering photos from others for this project. In Watanabe's case, being a *hikikomori* had been an ongoing lifelong intention, which ended suddenly. On the day he stepped outside, he photographed himself and his room. Watanabe says of this time "If you think of the period that you were secluding yourself as just a waste of time, it is difficult to accept, and makes it hard to restart your life. But if you photograph the way you and your room are, could you not turn all that time that has passed into a 'preparation period' for a photography piece?" By changing his way of thinking, he was able to re-enter society as an artist. He used the photographs that he took from that time as the icon for the website[4] of his current project.

The artist believes it is entirely possible to make the pains and struggles that come to you in life into something that has artistic value. For Watanabe, the project name, "I'm Here," is the voice of the *hikikomori*. Moreover the goal of the project is to stop people treating an invisible problem as if it is not real.

[1] The Japanese Ministry of Health, Labour and Welfare defines a *hikikomori* as someone who "does not go to work or school, has few or no social relations outside of the family, and is a recluse in their home for a period of more than six months. Hikikomori is, in fact, "not a single disorder or disability, but something that occurs due to a range of background factors," and it is said that there are over 1.1 million hikikomori in Japan.
[2] Watanabe made strenuous efforts to provide participants with the most appropriate agreements and to operate on the basis of consent, protecting the personal information of all contributors, ensuring the anonymity of all photographs, refusing to accept any photographs not from the subjects of the photographs, and paying gratuities to all participants.
[3] This includes some photographs from a similar project conducted in 2014.
[4] I'm here project website: https://www.iamhere-project.org/

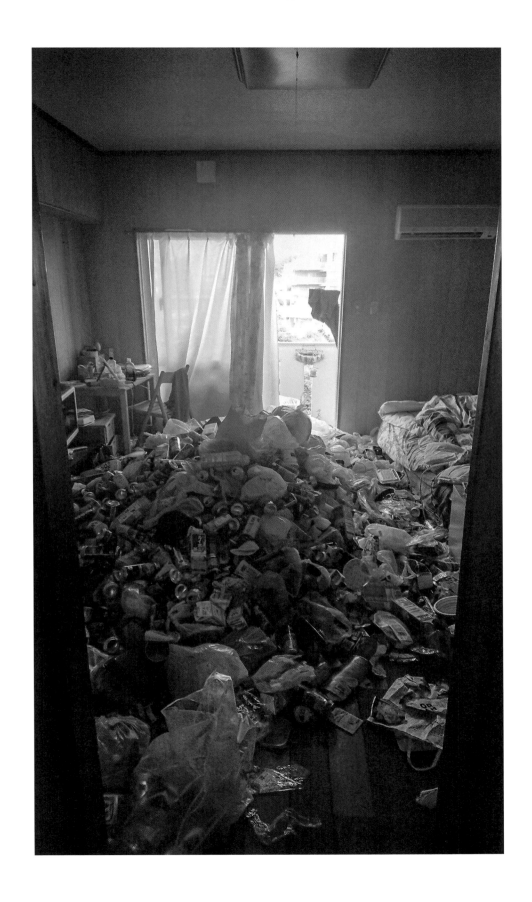

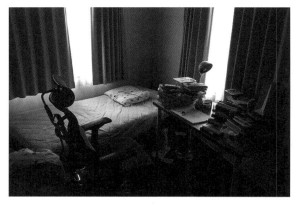
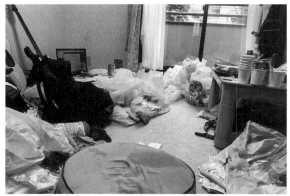
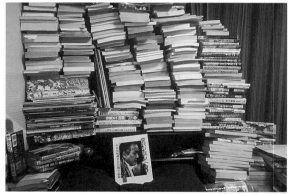
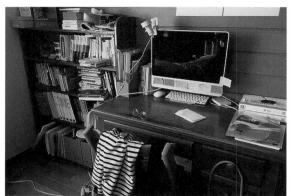
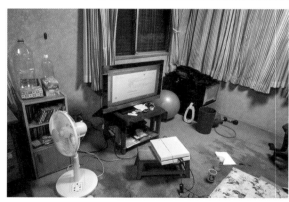
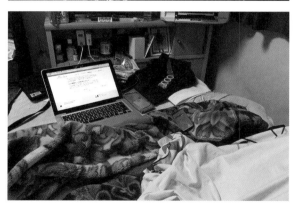
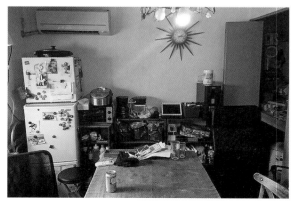
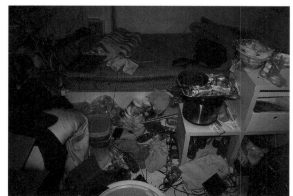

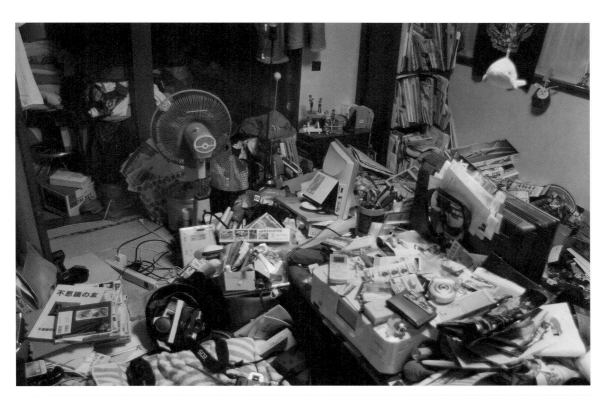

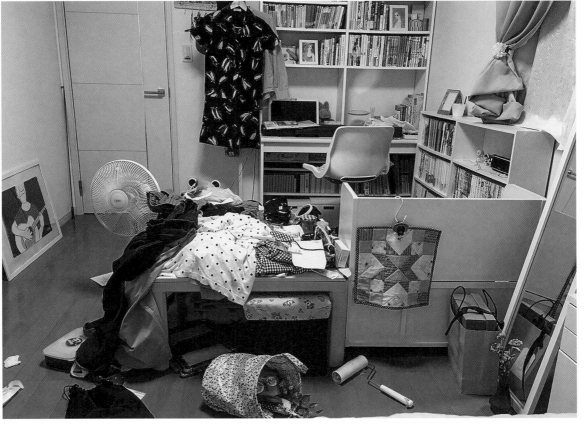

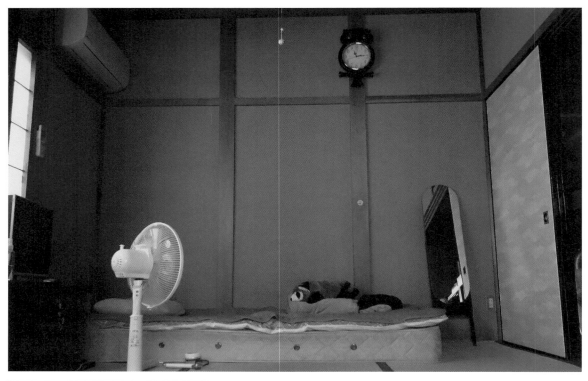

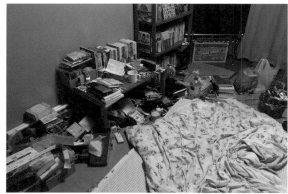

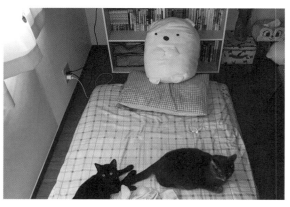

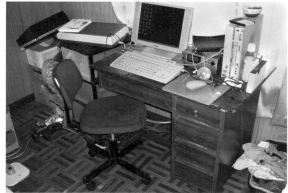

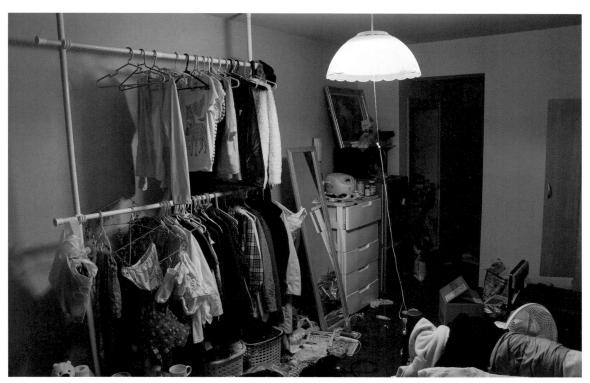

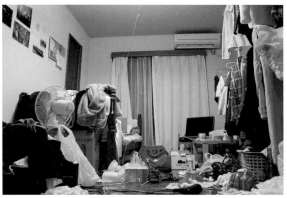

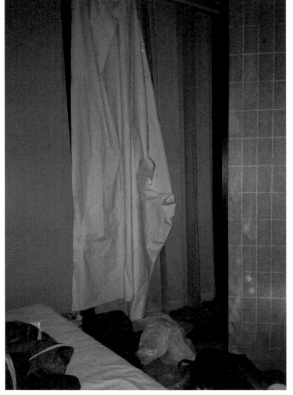

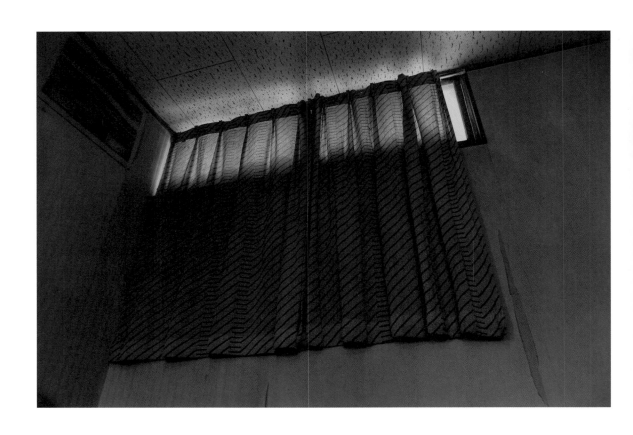

写真集『 I'm here project 』
Photo book "I'm here project"

仕様｜B6変形、52p（袋とじカバー、別紙付録2枚付き）
発行日｜2019年2月16日
編集｜アイムヒア プロジェクト
デザイン｜川村格夫
フォトディレクション・フォトレタッチ｜井上圭佑
校正｜秋山直子
英文校正｜Sam Stocker
英文校正補佐｜新江千代
解説｜天野太郎（横浜市民ギャラリーあざみ野 主席学
芸員、札幌国際芸術祭2020 統括ディレクター）
発行｜アイムヒア プロジェクト（代表：渡辺 篤）
助成｜アーツコミッション・ヨコハマ
写真撮影｜ひきこもりの方々
https://www.iamhere-project.org/

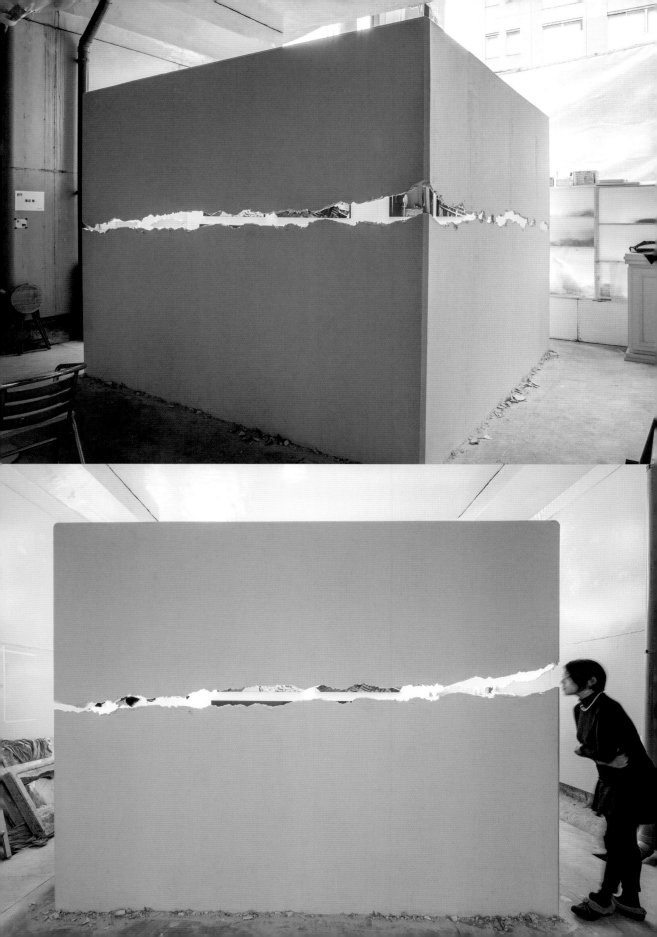

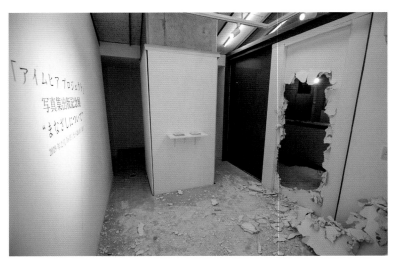

「アイムヒア プロジェクト」写真集出版記念展 "まなざしについて"
2019.02.16［土］17:00- ｜ 高架下スタジオ Site-A ギャラリー（神奈川）にて

"I'm here project" photobook publication commemorative exhibition "Gaze"
Installation view: Site-A Gallery Beneath the Railways, Kanagawa

「まなざしについて」

社会のどこにも居場所が無くなり、自室にひきこもった。学生を終えてすぐのこと。足掛け3年の当事者としてのひきこもりを終え、数年が経ち、最近では社会に居場所を手に入れてしまった自分が居る。

壁がある。壁はそこに両側がある事を示し、双方にとって他者が存在する事をあらわす。"ひび割れ／隙間" は、まなざしを他者に向けることをあらわす。

街を歩いていて、日常に "ひび割れ" がうまれることがある。例えば交通事故に遭った者にまなざしを向ける時、人は自分までもがその痛みを負ったように共感し寄り添って助けようともする。死んでいく人を「見届ける」というまなざしもあるし、何もできなくともその人の痛みがこの世にあったという事実を「せめて直視する」という眼差しもあるだろう。しかし、その一方で自分とは違う他者の奇異な状態（肉や骨の飛び出た傷口など）を「覗き見たい」と視覚が欲することも有る。人のまなざしは共感的で優しいものであり、同時に搾取的・暴力的で残酷なものでもあるのだと気づく。

けれどもまなざしは必ずしも "一方通行" ではない。例えば、鉄格子の中に閉ざされた動物もまた、檻越しに人間にまなざしを向けている。まなざしを向ける存在は、まなざしを向けられる存在にもなり得る。

私たちは、傷つけ幻滅させてしまったひきこもり当事者たちからも、まなざしを向けられているのかも知れない。部屋の外の社会で生きる私たちは、ひきこもりからもきっと見られている。暴力的なこの社会は「まだ許されてはいない" から、彼らは今日もひきこもり続けているとも言える。「背を向ける」というまなざしの存在の仕方もそこにはある。

ひきこもりがひとりでにひきこもりになるのではない。社会の中で共に生きてきた私たちのうちの誰かを、私たちは壁の向こうに追いやってしまった。小さなその部屋以外の居場所を奪ってしまった。そのことで幻滅され、背を向けられてしまっているのだ。

そうした反省に至る事も部屋の外に居る私たちにとって、関わりの再出発点に際し準備できることではないだろうか。

不可視の部屋の写真を見る時、私たちは自らの優しくて残酷なまなざしを知る。まなざしを向けられていることにも気付くかもしれない。彼らを変えるのではない。私たちこそが変わらなければならない。

"Gaze"

Right after I finished school, I realized that I no longer had a place in society, and I withdrew into my room as a hikikomori. I was a hikikomori for almost three years, but as the years since then have passed, recently I have found that I once again have a place in society.

Walls. Walls represent the fact that there are things on both sides, and they remind the person on each side of the other person's presence. "Cracks" represent turning your gaze on another person.

Walking around the city, these types of "cracks" appear in our daily lives. For example, when you cast your gaze upon a person involved in a traffic accident, you feel the pain of that person as if it were your own, and you attempt to draw close to help them. There is also a gaze that "sees off" a person who is dying, and even if you cannot do anything, you can "at least take a hard look" at the fact that that person experienced pain in this world. At the same time, there is also the "desire to look" at somebody other than you in an odd situation (with their flesh or bones protruding from an injury, etc.). A person's gaze can be a thing of sympathy, but we realize that at the same time it can be a thing of exploitation, violence, and cruelty.

Nevertheless, a gaze is certainly not a "one way street." For example, an animal locked up in a cage returns the gaze of a human watching through the bars. Someone casting a gaze can also become the subject of a gaze.

Maybe the injured and disillusioned hikikomori are returning our gaze as well. Surely the hikikomori see those of us living in society outside of their closed room. We who create this violent society have "not yet been forgiven" by them, so they remain hikikomori for another day. This suggests the type of gaze where a person "turns their back on someone."

A hikikomori does not become a hikikomori on their own. These individuals who previously lived alongside us in society, we have forced them to the other side of the wall. They have lost their place in society, with only that small room remaining. That has caused them to be disillusioned, and people have turned their backs on us.

Is it possible that reflecting on this situation, for those of us outside that room, is an opportunity to prepare to restart a connection with them? When looking at these "photographs of invisible rooms," we become aware of our own gentle and cruel gaze.

We might even realize that we are being gazed upon ourselves. The solution to this problem is not to change them. We ourselves must change.

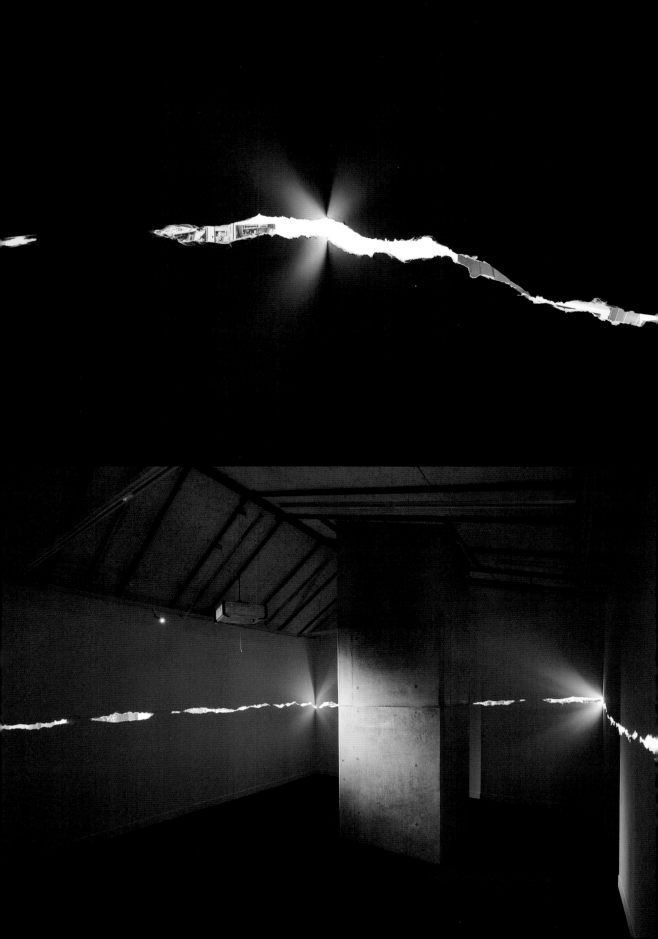

「I'm here project」写真集出版記念展
"まなざしについて"オープニングパフォーマンス
2019.02.16［土］17:00-
高架下スタジオ Site-Aギャラリー（神奈川）にて

"I'm here project" photobook publication commemorative exhibition
"Gaze" opening performance
2019.02.16 [Sat] 17: 00-
Performance scenery: Site-A Gallery Beneath the Railways, Kanagawa,

オープニングパフォーマンス。初日、開場の段階では展示室の入口が
石膏ボードを素材とする、扉の形状の壁によって塞がれている。あらか
じめ展覧会告知において、携帯をお願いしていたカナヅチを持ってき
た来場者約80人らと展示室の入り口扉を叩き壊して内部に入場した。
"寄り添いや優しさ"と、"搾取性や暴力性"が「介入する」際の動機と
して綯い交ぜになって発生する。孤立者を見つめる自らのまなざしに
内包される意識について。その自覚や自己批判を誘発する行為として
の打破。
社会問題としての孤立は、当事者の存在や言葉も社会から取り残され、
不可視化していく。そこには直視することの必要性がある。対して、ジャー
ナリズムの名の下に孤立者（例えばひきこもり）の姿を、その部屋に無
理に押し入って搾取的に撮影する手法（ひきこもりに対する暴力的支
援団体が扉を蹴破って当事者の部屋に入り込んだり、施設に軟禁する
などの行為）が、倫理的な社会問題ともなっている。我々は社会と断絶
することを選ばざるを得ずに孤立した者とどう接近すればいいのだろ
うか。

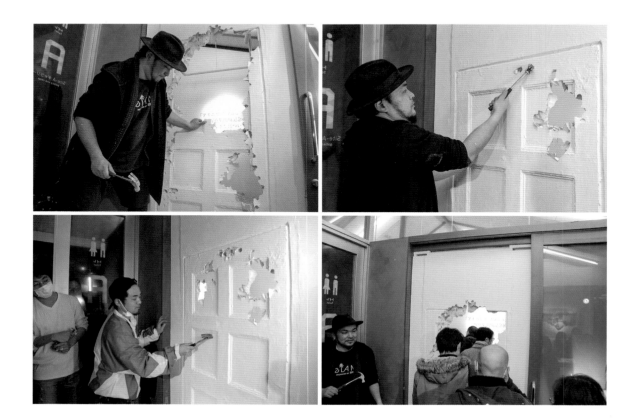

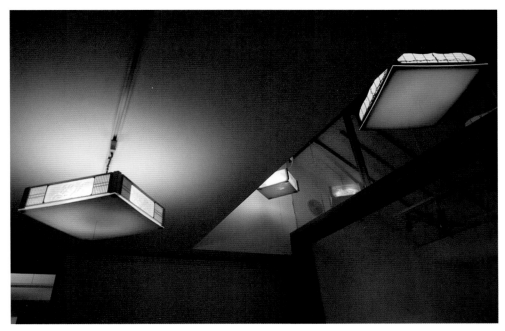

《空を見せたい》
2019年｜和室シーリングライト、アクリル板、写真

Look at the sky
2019 | Japanese style ceiling light, acrylic board, photo

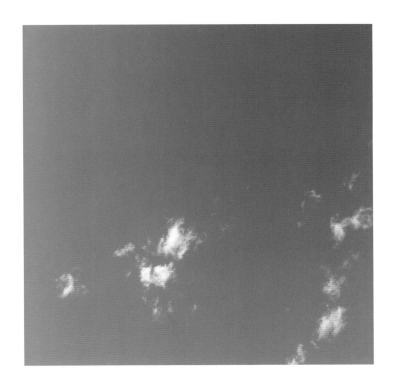

ひきこもり当時の私はカーテンを締め切り、空を見ることは全くなかった。外が快晴であればあるほど、その空の下で人は生産性をあげることができる。ある者は仕事が捗り、ある者はレジャーに出かけ、ある者は愛を育む。青空はその下に居る者にその価値を届ける。だからこそ、部屋にのみ居続けるひきこもり当時の私にとって、空が青々と快晴であればあるほどその幸福を運ぶ強い光と爽やかな色を見るのが辛かった。孤立は辛い。けれど、孤立は孤立を維持し続けなければそれもまた辛いのだ。カーテンを閉じ切った。

ひきこもりの最中、当時見続けていたインターネットのストリーミング配信。一部の一般配信者たちはノートパソコンを持って屋外に出かけ、様々な街の様子を放送し続けていた。それを毎日、起きている間中横になってずっと視聴していた。不思議とノートパソコンに映る屋外の世界には嫌な気がしなかった。媒介／メディアを通した空の色は、部屋の中にこもり続けている者にも、優しく届いたのだった。

和室シーリングライトにはめ込まれている"青色"はアイムヒア プロジェクトでひきこもり当事者に写真募集をしていた期間の快晴だった日に私が撮影した青空の写真。

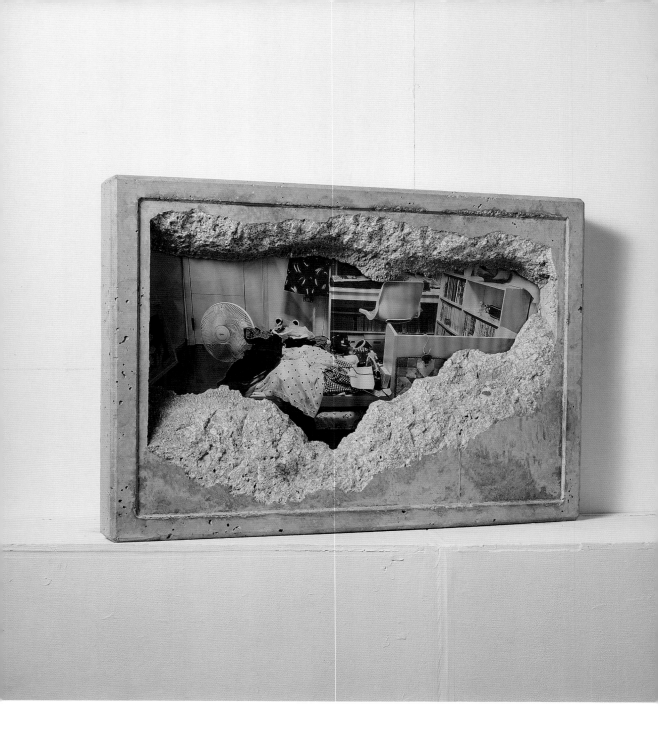

《GAZE_01》
2019年│写真、強化ガラス、コンクリート
共同制作：F氏（ひきこもり当事者）

GAZE_01
2019 | Photograph, Tempered Glass, Concrete
Collaborative production: Ms. F (hikikomori)

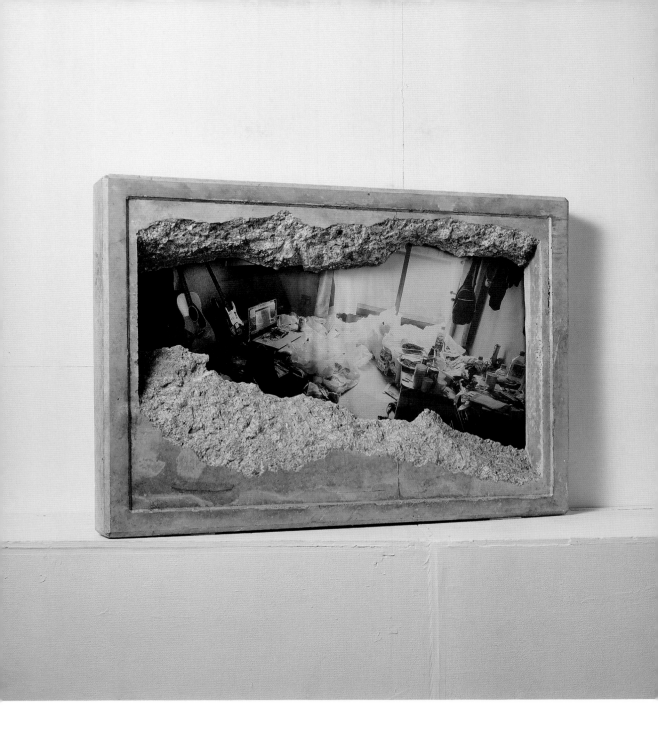

《GAZE_02》
2019年｜写真、強化ガラス、コンクリート
共同制作：A氏（ひきこもり当事者）

GAZE_02
2019 | Photograph, Tempered Glass, Concrete
Collaborative production: Mr. A (hikikomori)

切実な時間の彼方へ

福住 廉
［美術評論家］

ソーシャリー・エンゲイジド・アート（以下、SEA）とは「特定の人びとに深く関わりながら、何らかの変革を生み出す」[*1]ことを目指すアートである。「社会関与の芸術」とも訳されるこの潮流は、1990年代にはじまり、現在では現代美術を代表するひとつの様式として定着して久しい。ひきこもりを含む社会的弱者に関与しながら、彼らの小さな声を作品の中で昇華することで、直接的にせよ間接的にせよ、何らかの解決や救済を試みている渡辺篤はSEAのアーティストとして位置づけることができよう。いや、少なくとも日本におけるSEAのもっとも傑出したアーティストと言っても過言ではないのではないか。

そのように高く評価できる理由は、おもに2つある。第一に、関与の程度が他に類例を見ないほど深いこと。第二に、その一方で、そのような関係性を作品として確実に物質化していること。この2点を両立しうるアーティストは思いのほか少ない。

渡辺篤はひきこもりの状態から自らを解放した経験がある。その切実な当事者性は「アイムヒア プロジェクト」を成立させる重要な求心力である。彼が元ひきこもりであるからこそ、ひきこもりの当事者たちは、自閉の公開という矛盾を引き受けたのだろう。ひきこもりに限らず、精神的な傷を共有しうる濃密な関係性を維持し

ている点は、他のSEAのアーティストには見られない、彼ならではの特質であると言ってよい。アートプロジェクトであれ芸術祭であれ、いまや社会の現場に介入するアーティストは少なくないが、それらの関与はおおむね部分的かつ限定的、何より一時的であり、ある特定の問題を作品化するやいなや、別の問題へ軽やかに転じていく場合が多い。

SEAが抱える本質的な矛盾は、それが社会への関与を深めれば深めるほど、作品として結実させる必然的な理由を失っていく点にある。事実、SEAを包括する名称として「ソーシャル・プラクティス」が用いられているのは、それが必ずしも芸術を志向しない、いや、むしろ芸術という概念を積極的に不要とする場合があるからだ。つまり、作品の形式的な完成度と関係性や実効性はしばしば矛盾する。だが、渡辺篤の作品はつねに双方を有機的に両立させたうえで成立している。傷を金継ぎで修復する技法だけではない。たびたび採用しているコンクリートには圧縮に強く引張に弱いという特性があるが、これはさまざまな人間関係に翻弄され内向的にならざるを得なかった精神的な弱者の心のありようを的確に反映した素材である。テーマとメディウムを見事に調和しているわけだ。

とはいえ、渡辺篤による「アイムヒア プロジェクト」は、ひきこもりの直接的な解決策になりうる

のだろうか。SEAを構成する要素として「変革」がある以上、ひきこもりの親たちが「特効薬」や「救世主」を求めがちなように、「アイムヒア プロジェクト」がそのような期待を集めるのも無理はない。斎藤環はひきこもり治療のゴールとして「複数の親密な仲間関係をもつこと」を挙げているが[2]、「アイムヒア プロジェクト」がそのような親密圏のひとつになりうることは間違いないだろう。けれども、私たちは「変革」の成否を性急に求めてはならないのではないだろうか。なぜなら、ひきこもりとは、究極的に言えば、私たちが生きる近代という時間とは異なる時間を生きる状態として考えられるからであり、そうである以上、近代的な時間軸から「変革」の成否を判断することは不可能だからだ。

ひきこもりの支援活動に従事している田中俊英によれば[3]、ひきこもりの子をもつ父親は「自立」に、母親は「愛情」に、それぞれ強迫的に苛まれていることが多いという。父親は自立できない子に権威的に自立を迫り、母親は愛情の過不足にひきこもりの原因を求めながら自らを責め、子はますますひきこもっていく。こうした家族の現場に顕在化しているのが、じつのところ近代という価値観にほかならない。近代こそは「家族愛」をもとに「自立」を説き、「原因」の解明による「解決」という「合理性」を尊んできたからだ。えてして親たちが子の自発的な解放を待ち難いのも、おそらく彼らの心底に「自立」から「結婚」、そして新たな「家族」という近代の時間性が大きな影を落としているからではなかったか。

「アイムヒア プロジェクト」に見出すことができるのは、それぞれ異なる固有の時間性である。壁の裂け目の向こうには、近代の時間性から相対的に自律した、もうひとつの時間が流れている。たとえ時間が止まっているように見えたとしても、それは私たちが近代という色眼鏡をかけているからなのかもしれない。そのフィルターを外してみれば、当事者の苦悩があらゆるものやことになりうる可能性の海を漂っている光景を見ることができるはずだ。現代美術の可能性とは、可能性が現実化しうる可能性を垣間見せる点にある。渡辺篤はSEAに収まらない新たな美術をいずれ生み出すにちがいない。

※1 工藤安代「はじめに」、『ソーシャリー・エンゲイジド・アートの系譜・理論・実践』フィルム・アート社、2018年
※2 田中俊英『「ひきこもり」から家族を考える 岩波ブックレット739』岩波書店、2008年
※3 斎藤環・畠中雅子『ひきこもりのライフプラン 「親亡き後」をどうするか 岩波ブックレット838』岩波書店、2012年

Beyond Imposed Time

Ren Fukuzumi

[art critic]

Socially Engaged Art (SEA) is an art form that aspires to "generate some kind of reform while be-ing deeply involved with specific people."*1 This movement, which is also referred as the "art of so-cial involvement," was initiated in the 1990s and has long been established as one of the representa-tive forms in contemporary art. In his attempts, either directly or indirectly, to find solutions or rem-edies for the *hikikomori* [social recluses], Atsushi Watanabe could be characterized as a SEA artist; he has integrated the socially vulnerable into his artwork by dint of sublimating their weak voices. It would hardly be an overstatement to state that Watanabe is the most outstanding proponent of SEA in Japan.

There are two key reasons to evaluate Watanabe so highly. Firstly, the unprecedented depth of his involvement. Secondly, and conversely, he has ensured that such relations materialize as artworks. Few artists are capable of achieving such a balance between these two aspects.

Watanabe has experienced liberating himself from a state of withdrawing from society. His compel-ling experience of having been a recluse has been a crucial centripetal force in him establishing the "I'm Here Project." Given the fact that Watanabe himself was a *hikikomori* in the past, the recluses who participated the project likely let him uncover the contradictions inherent in disclosing social withdrawal. What is unique to Watanabe—and not to be observed in the works of other SEA art-ists— is that his work is not confined to the *hikikomori*, but also involves

maintaining close relation-ships in which emotional scars can be shared. While nowadays art projects, art festivals, and numer-ous artists have been getting involved in the social realm, their engagement is largely one-sided and limited, and above all transient, for no sooner than those artists render a specific issue into an art-work, they often quickly turn and focus on another issue.

SEA's inherent contradiction lies in the fact that the deeper it gets engaged with societal issues, the more it loses the inevitable reason to bring its involvement to fruition as an artwork. The very fact that the term "social practice" is employed as a generic term for SEA would suggest that is not art-oriented, or rather, to be more precise, that it does not require the concept of art. In other words, an artwork's formal perfection often constitutes a contradiction in terms of its relationships and its ef-fectiveness. Watanabe's artworks, however, invariably have been contingent upon organically bal-ancing these two contradictory factors. In his case, it is not simply a matter of applying the *kintsugi* technique to repair a scar with a lacquer mixed with gold. The concrete he frequently employs is characterized by how robust it is in terms if compactness and yet weak in tension. As a raw material it accurately reflects the mental state of the mentally vulnerable who have been impelled to be in-troverted on account of various human relationships in their lives. Theme and the medium are in perfect harmony.

And yet, does Watanabe's "I'm Here Project" offer a direct solution to those living as isolated re-cluses? Besides the fact that "reform" is a vital element in Socially Engaged Art, it is hardly surpris-ing that the "I'm Here Project" awakens such expectations given that the parents of recluses tend to seek out all types of "magic bullets" and "saviors." Tamaki Saito once remarked that the treat-ment for *hikikomori* aims at enabling them "to enjoy multiple close friendships";[2] the "I'm Here Pro-ject" can surely become one such intimate sphere. That said, we shouldn't hastily look for the success or failure of such a "reform"? Because, ultimately, being a social recluse is considered as a state of living in a time different from the modern times in which we live, and as such, the success or failure of such a "reform" cannot be evaluated in terms of the modern time axis.

According to Toshihide Tanaka, who is engaged in support activities for the *hikikomori*,[3] fathers of socially reclusive children are often obsessively tormented by the notion of "autonomy" whilst mothers in a similar predicament are tormented by the notion of "affection." The father authorita-tively imposes autonomy upon a child who cannot become independent, whilst the mother blames herself for being the cause of their child's withdrawal on account of her excess or lack of affection, which results in the child becoming increasingly isolated. In fact, what is at play in such a family set-ting is nothing other than contemporary values. This is because our modern way of life has advocat-ed the notion of

"independence" predicated on "family love," and has come to value the "rationali-ty" of "solutions" by elucidating the "causes." Isn't the reason parents can't wait for the voluntary release of their children probably due to the modern timeline that casts such a huge shadow over their hearts, a timeline stretching from "autonomy" to "marriage" and thereafter to a new "family."

What the "I'm Here Project" can discover is each and everyone's unique temporalities. Beyond the breach in the wall, another time flows, one that is relatively autonomous from modern temporality. Even if it appears as though that time is at a standstill, it might be because we are wearing moder-nity's tinted glasses. If we remove that filter, we should be able to see the sight of the *hikikomori*'s suf-fering floating on the sea, a sea where their suffering has the potential to be anything and everything. The potential of contemporary art lies in its ability to afford a glimpse of possibilities that can be realized. Atsushi Watanabe is of the belief that sooner or later he must bring forth a new form of art that does not fit in with Socially Engaged Art.

*1 Yasuyo Kudo "Introduction," *The Genealogy, Theory, and Practice of Socially Engaged Art*, Film Art Sha, 2018
*2 Tanaka Toshihide, T*hinking about the Family in terms of "Hikikomori"* Iwanami Booklet 739, Iwanami Shoten, 2008.
*3 Tamaki Saito and Masako Hatanaka, Hikikomori's *LifePlan: What to Do After the Parents's Death*, Iwanami Booklet 838, Iwanami Shoten, 2012.

WRAPPED IN ISOLATION
7 DAYS OF DEATH

孤立を憑依させる 七日間の死

1畳サイズのコンクリート製の造形物を展示室に設置し、1週間その中に身体拘束をしたのち、自力で脱出をした《止まった部屋 動き出した家》（2014年）。それから多少形式を変えて再演を行なった本作。屋外に設置した直方体の造形物に自身を密閉するパフォーマンスを行い、それを映像として残すため7日間定点撮影を行った。

精神や身体の危険が伴うこの過酷なパフォーマンスは、"とらわれからの再生"について、私自身のひきこもり経験を踏まえて表現している。私の過去のその経験は、時が経った今思うと、山岳修行における「擬死再生（一旦死んで生まれ変わること）」や仏教由来の「内観」※にも通じる部分があったようにも思えてくる。

ひきこもりとは、多くの場合、修行のように自ら進んでそれを行うことではもちろんない。より良く生きるために選び取ったというよりは、むしろ消去法のような経緯で部屋に居るしかなくなってしまったことを言うのだろう。そこには絶望や逃避があったりもする。またある見方をすれば一旦は社会的に死んだようにもなる。

しかしひきこもることとは、時として究極的に自己と対峙し、やがて永い時間の中で大事な気づきを得て、そして再びこの生きづらい社会で逞しく生きていくために必要な通過儀礼なのかもしれない。まるでサナギのように動かなくなるその時間も価値あるものとして再定義したい。

※「内観」：ここでいう内観は、僧侶の吉本伊信（1916-1988年）が浄土真宗系の信仰集団に伝わっていた自己反省法・「身調べ」から苦行色や宗教色を取り除いて、万人向けのものとした修養法を指す。両親をはじめとした身近な人に対する自分を、1週間こもって予め決まった3つの観点に絞って深く反省をする。起床後は「半畳」、就寝時は「一畳」の場所にこもって行う。私は足掛け3年のひきこもりを終えたのちに実際に2度、医療施設で内観を経験した。

In 2014, I created Suspended Room, Activated House, in which I installed a single tatami size (approximately 1.65 square meter) concrete facility in the exhibition space and holed myself up for a week inside until I escaped on my own. This piece was a slightly different iteration of that performance. It required me to be sealed in a small rectangular facility installed outside, with a direct camera feed set up for seven days recording footage from inside.

A harsh performance that posed real risks to both my body and mind, it was intended to express rebirth from imprisonment, based on my own experiences as a hikikomori. Looking back on those old experiences as time has passed, I've come to feel that they share a number of things with concepts like gishisaisei (momentarily dying and being reborn) that takes place in mountain asceticism, and *naikan** that forms the fundamental basis of Buddhism.

In most cases, of course, being a *hikikomori* is not something someone willfully takes on like ascetic training. It isn't a path a person chooses to take in order to lead a better life, but rather a means of describing a situation whereby a person becomes unable to leave their room through a kind of process of elimination. It can also be tied to despair and the desire to escape from reality. Taking another viewpoint, one could equally see it as dying for a period on a societal level.

Still, in certain cases, living as a *hikikomori* may act as an ultimate means of coming face to face with oneself; it may be a necessary rite of passage in order to brave the harshness of society once again after coming to important realizations over a long period of time. I would like to see it redefined as something that has value, akin to the period when a chrysalis sits without moving.

*Naikan: Naikan here refers to a universal means of self-discipline, removed from an atmosphere of penance or religious adherence, through mishirabe, a process of self-reflection, which was taught to religious groups of the Jodo Shinshu school by Buddhist Ishin Yoshimoto (1916-1988). Over the course of a week, an individual must engage in deep reflection from three fixed, focused viewpoints on themselves in relation to those close to them, beginning with their parents. Waking hours are spent enclosed in an area no bigger than half a tatami mat, and one sleeps in an area the size of a single mat. I experienced naikan myself twice in a medical facility after spending nearly three years as a hikikomori.

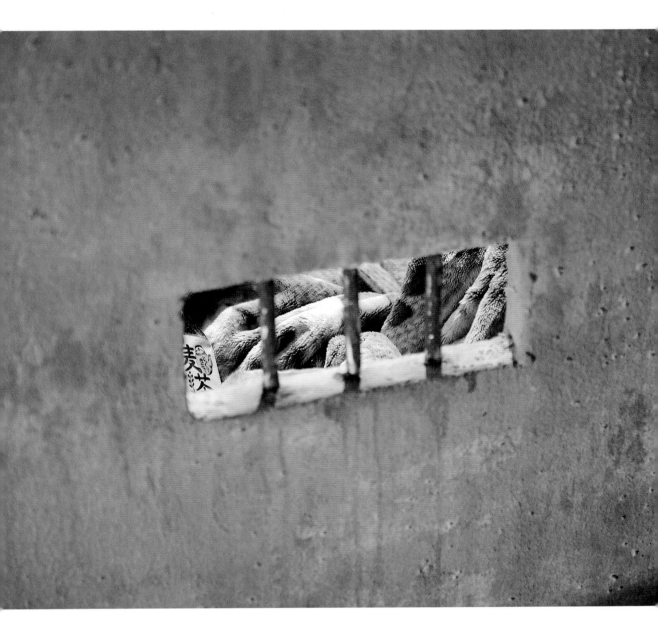

《七日間の死》
2019年｜パフォーマンス、インスタレーション｜コンクリート
展示風景：「雨ニモマケズ（singing in the rain）」（R16スタジオ、神奈川）

7 DAYS OF DEATH
2019 | Performance, Installation | Concrete
Installation view: "Ame ni mo makezu: singing in the rain" (R16studio, Kanagawa)

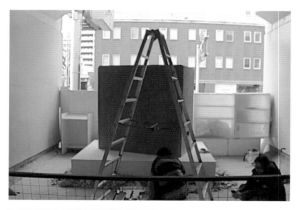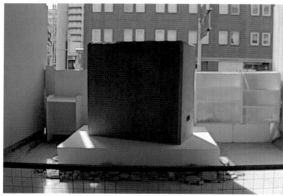
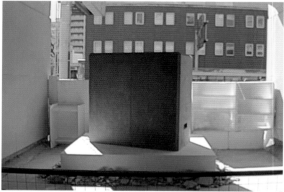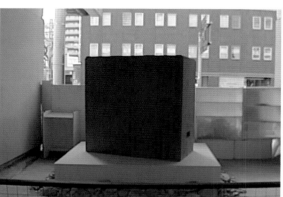
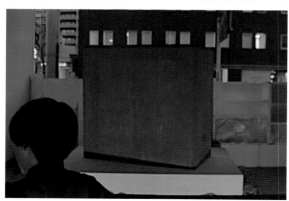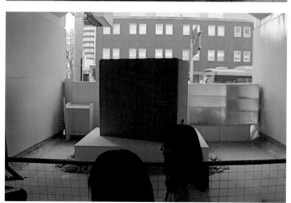
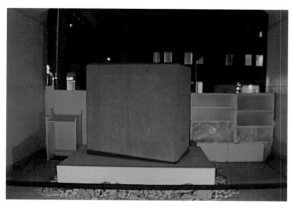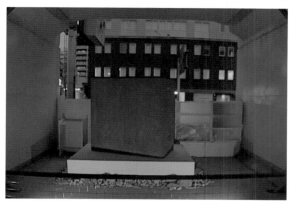

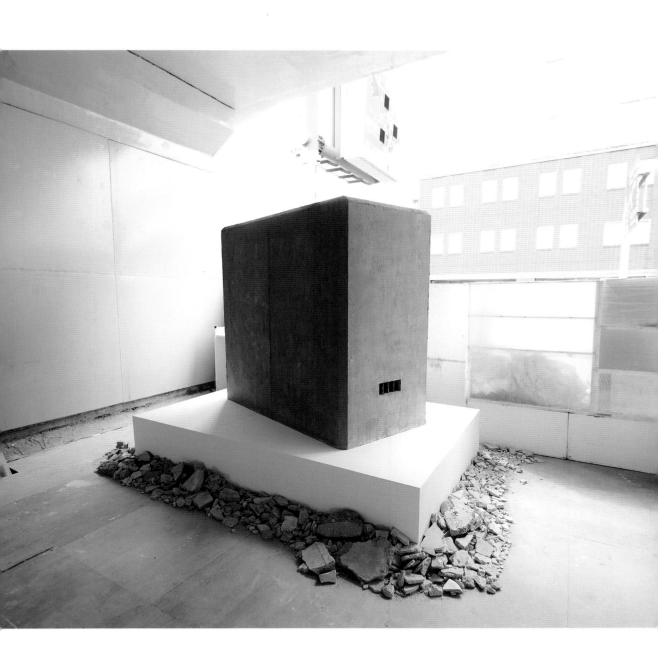

公開型のパフォーマンス。生放送をインターネットで行った。
部屋で孤立している人でも観られるように。

Performance. Hikikomor people could see this as well.
Because this work was broadcast live on the Internet.

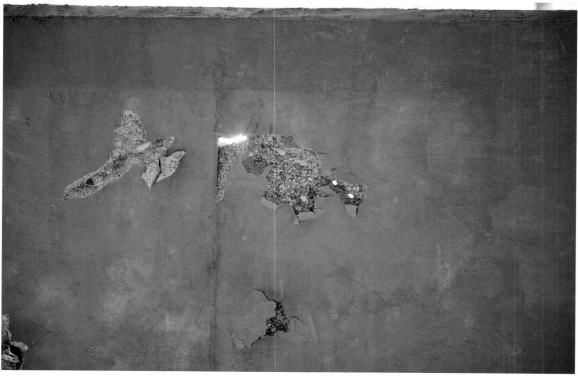

会場にはコンクリートを叩くカナヅチの音が響く。
The sound of a hammer hitting the concrete was echoing in the venue.

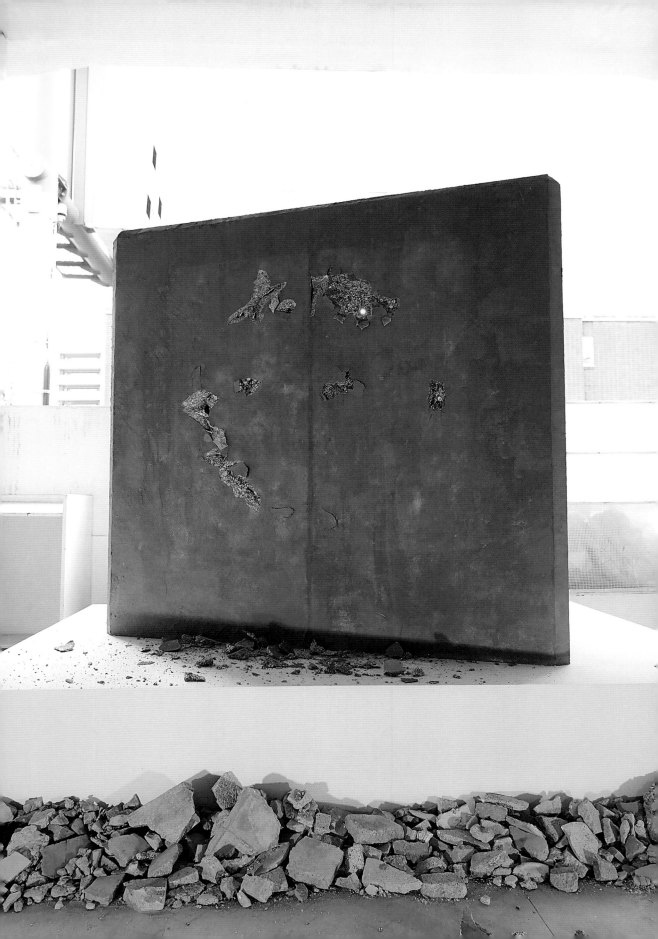

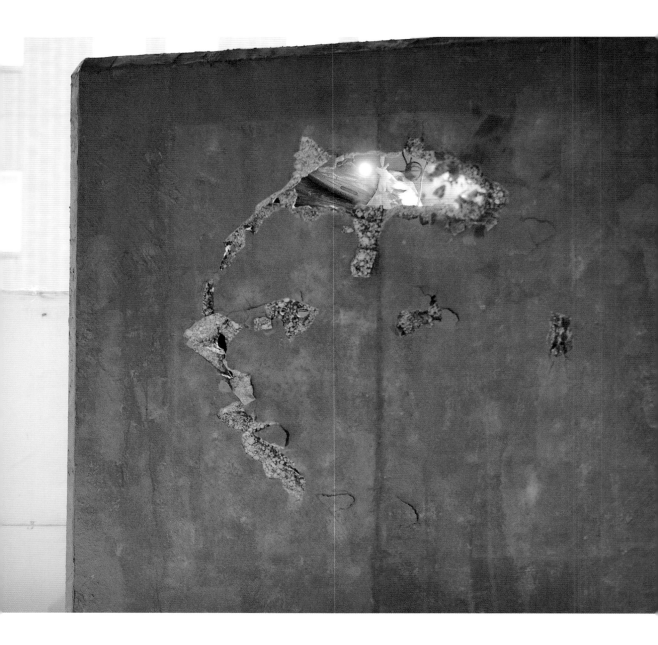

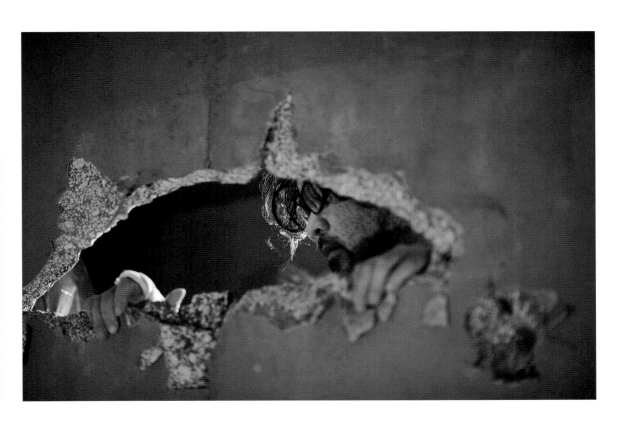

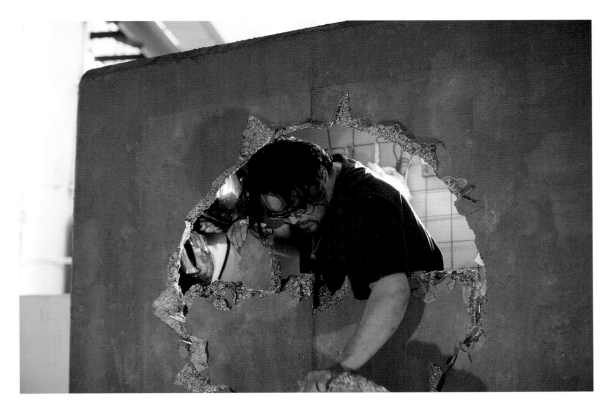

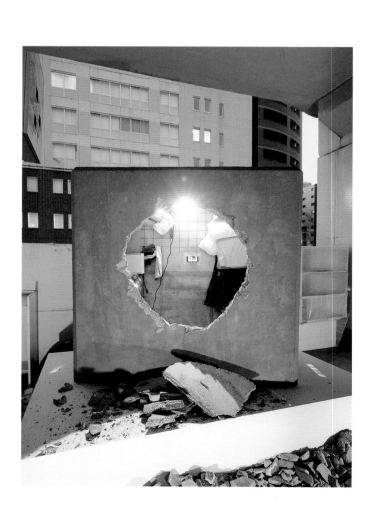

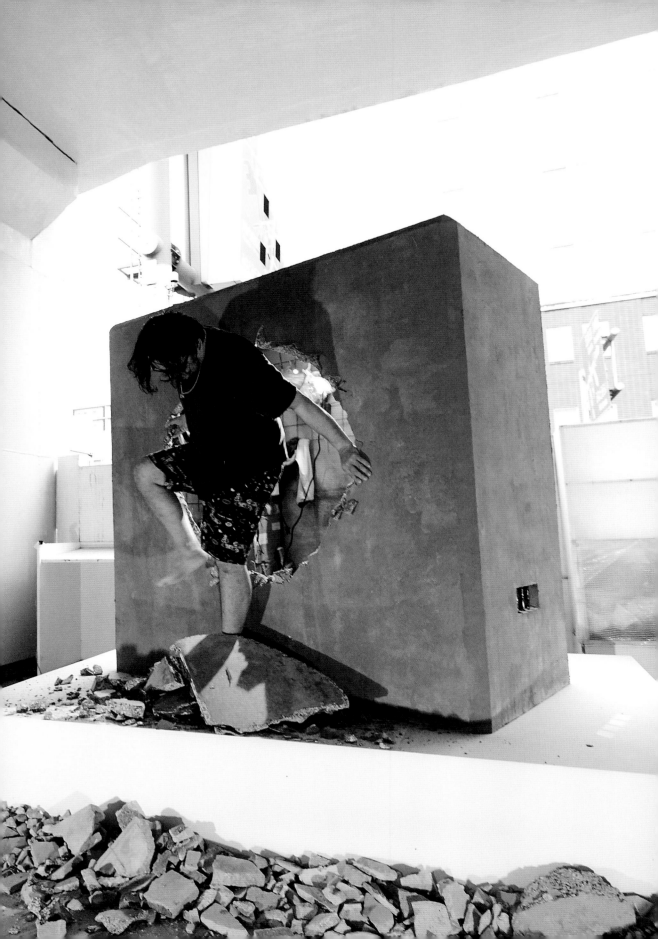

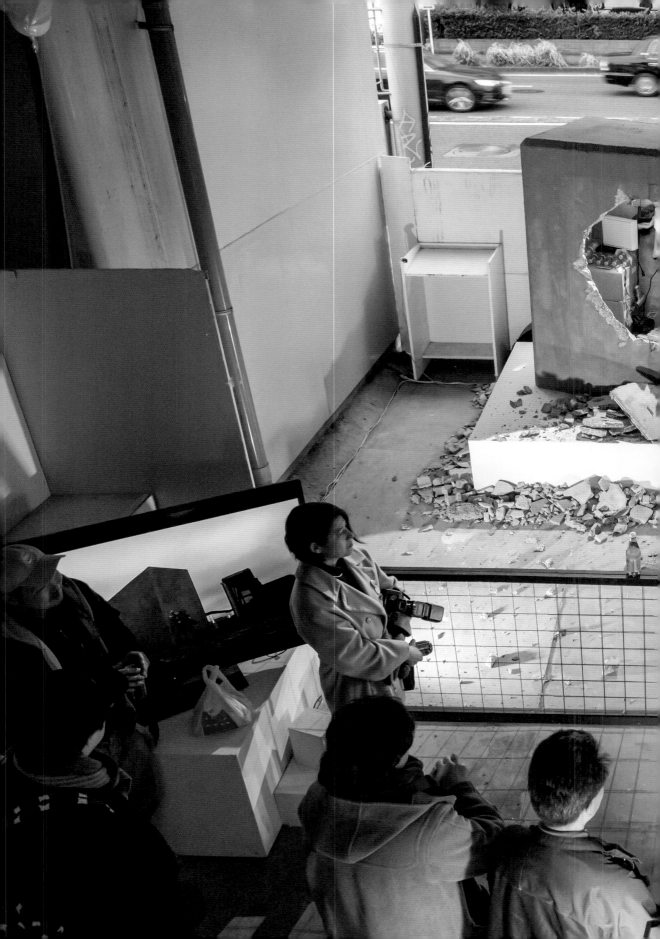

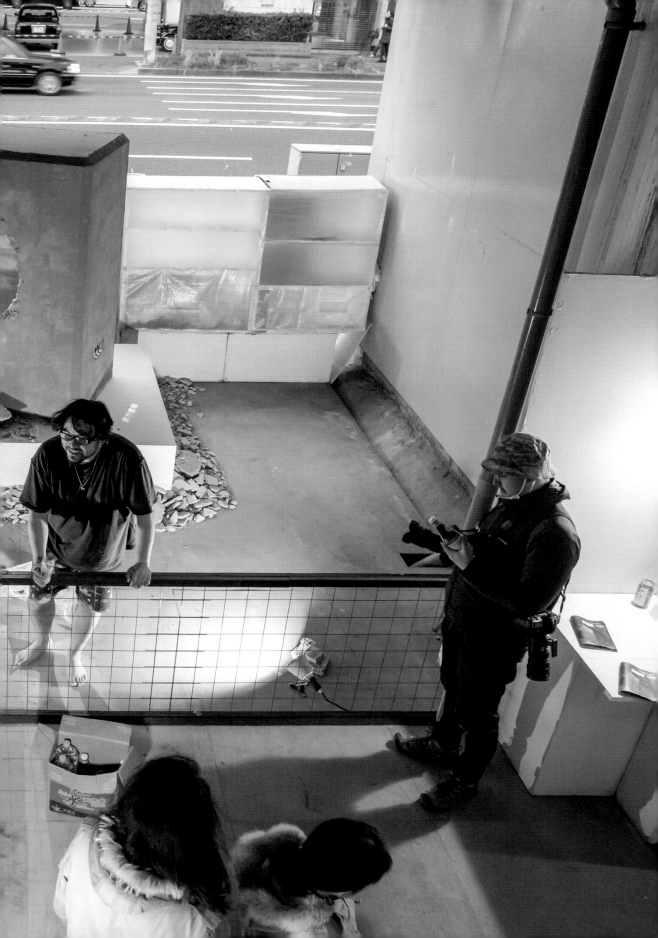

RECOVERY

Project "Monument of Recovery"

プロジェクト「修復のモニュメント」

ひきこもり当事者／経験者が孤立に至った原因や生きづらさの事情について、渡辺篤と対話しながら、コンクリート製の記念碑を作るプロジェクト。碑を敢えて一旦ハンマーで破壊した後、陶芸の伝統的修復技法「金継ぎ」によって再構築する。見過ごされ、抑圧され続けてきた声の顕在化によって、伴走型の新しい当事者発信の形を模索する。

Atsushi Watanabe created the concrete monument for the project "Monument of Recovery" through conversation with the *hikikomori*: why they had to be impelled in isolation and how they became socially introverted. After the concrete door purposely destroyed using a hammer, the *kintsugi* or the traditional Japanese repair technique was applied in order to repair the broken pieces of concrete. By rendering confined voices tangible, the project challenged a new art form that involves specific people such as social recluses.

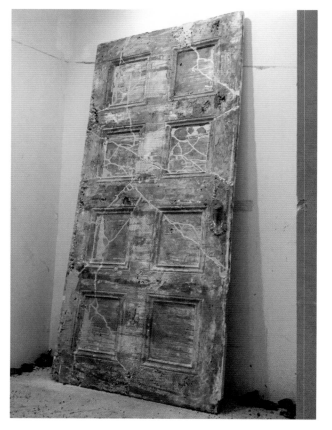

《修復のモニュメント「ドア」》
2016年｜インスタレーション｜ビデオ、コンクリートに金継ぎ
展示風景：「黄金町バザール2016」（神奈川、2016年）

Monument of Recovery "The Door"
2016 | Installation | Kintsugi to concrete
Installation view: "Koganecho Bazaar 2016"

今はもう存在しない記憶の中の扉をコンクリートで再生した後、また壊し、そして金継ぎ修復を施した。
以下は「アイムヒア プロジェクト」ウェブサイトより引用
——ひきこもっていた私にとって、もはや自分自身ではその状況から脱することができなくなっていた頃、頼みの綱は母の存在だった。けれど、母は、自身の想像を越えた困難に認識が追いつかなかったようで、手をこまねき、当初は「助けたい」と言ってはくれたものの、結果的には何ヶ月も扉をノックすらしてくれない日々が続いた。やがて私は母からも見捨てられたと感じ、いよいよ一生この部屋から出ずに死んでいくのだと覚悟し始めた。しかし、心の深い底には、僅かながら自然と湧き出る怒りもあったのだ。同じ家の中で社会的撤退を今なお続けている息子を助け出してくれない母に対して、段々と恨みの感情が芽生えていき、ひきこもった当初の、社会への恨みから矛先が意向し、母への怒りも高まっていった。ひきこもってから随分と月日が経ったある日、私の怒りはいよいよ爆発して、母の居るリビングの扉を蹴破った。「扉はこうやって開けるんだよ!!」と怒鳴った。それは、困窮した息子を放置し続ける、母に対しての必死のアピールのつもりだった。
しかし、そのことは私の思いに反し、状況をますます悪化させた。物音を聞き付けた父は、家に迷惑物の怪獣が現れ、その悪を成敗するために現れたヒーローかのように振る舞い、とはいえ結局は父自らではどうすることもできず、警察を呼んだ。——

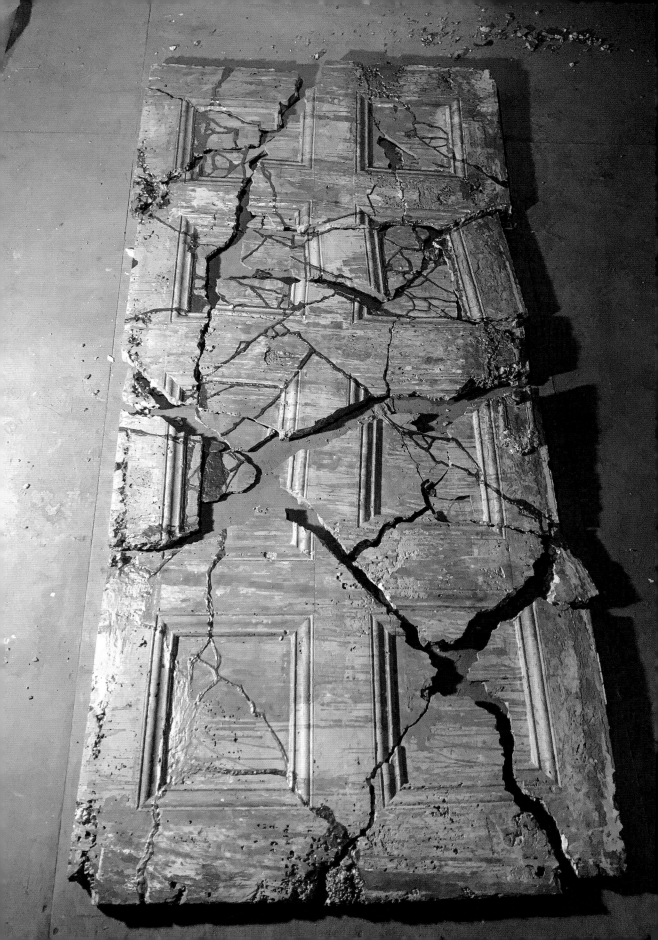

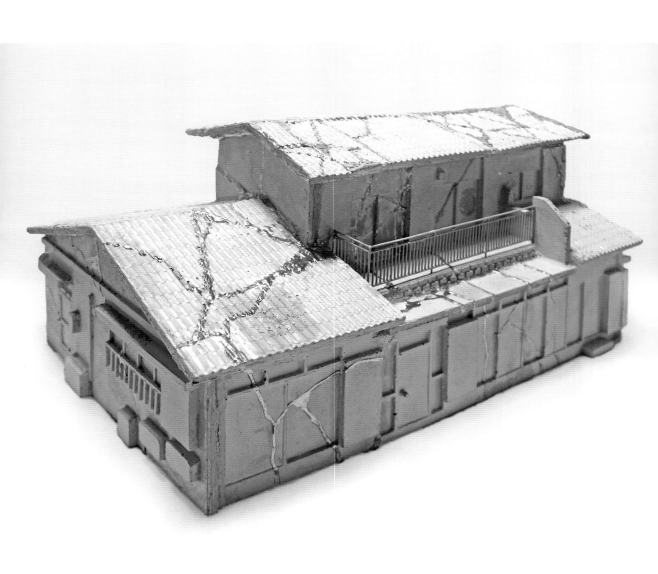

《修復のモニュメント「家」（わたしの傷／あなたの傷）》
2017年｜インスタレーション｜ビデオ、モルタルに金継ぎ
共同制作：渡辺家の母｜原型製作：Hidemi Nishida

Monument of Recovery "The House" ("My wounds / Your wounds")
2017 | Installation | Video, Kintsugi to mortal
Collaborative production:Watanabe's mother
Model prototype production: Hidemi Nishida

I restrained my desires.

Why are we seeing more and more hikikomori in our society?

私と母親との合作である。昔、私がひきこもっていた時の、扉の「こちら（私）」側で持っていた傷やその痛みの体現は、同時に扉の「むこう（母）」の側の傷にもなっていた。そのことに気づいてしまったことが私がひきこもりを終えた理由のひとつでもある。

ひきこもって3ヶ月ぐらい経った頃だったか。扉の向こうで一度だけ「助けたい」と言ってくれたものの、それから数ヶ月間扉をノックすらしてくれなかった母。次第に怒りがこみ上げ、ひきこもった当初のきっかけよりも、その見捨てられた様にも感じられた境遇に対し、怒りは小さな部屋を充満させ溢れ出るほど膨らみ続けていった。しかしある時、どのように関わればいいのか悩み続けて硬直し、扉の向こう側で憔悴しきっていた母の姿を知ることになる。

この作品では、モルタルで作った渡辺家の家屋のミニチュアを、ハンマーを用いて両者で一旦叩き壊し、その後、当時を振り返る対話や痛みの告白をしながら、2人で修復を試みている。

私自身が過去に負った深い傷や、底なし沼のようなとらわれは、自分以外の誰かの傷に気づくことや、アートにおける発表活動と向き合うことで昇華されていったのだろうと思う。

とらわれは、自分を客観視出来た時にその固まったロックを外すことが出来る。一人で心悩むときにこそ、誰かの傷に気づき痛みに寄り添うことは、自分の痛みへの近視眼的な執着心を和らげる。つまりそれは人を救い、また、自分自身をも救うことになる。

見殺しにされたくない弱い私は、傷ついた誰かの痛みを知る必要がある。

誰もが見殺しにされない社会を私は作りたい。

This is a collaboration between my mother and myself. Back in the days when I was living as a hikikomori, the wounds I bore on my side of the door and the pain they embodied also caused wounds for the other side of the door (my mother's). This realization became one of the reasons why I ceased to be a hikikomori.

Once, I think around three months into my time as a hikikomori, my mother told me from the other side of the door that she wanted to help. But after that, several months passed without so much as a knock. I quickly grew enraged, less at the reasons that had made me a hikikomori to begin with, and more towards the circumstances that had left me feeling as if my mother had abandoned me. And my rage continued to swell and filled up the tiny room as if it would burst outside. There came a moment, though, when I suddenly became aware that my mother had been paralyzed with constant concern about how to approach me, and that on the other side of the door, she was wasting away to skin and bones. With this work, my mother and I use hammers to completely destroy a miniature version of the Watanabe family home I've made from mortar, and attempt to rebuild it together while looking back at and discussing those days, and letting each other know the pains we each suffered then.

I believe that the deep wounds I bore in the past and my imprisonment in what felt like a bottomless swamp were sublimated by my becoming aware of other people's wounds and through my engagement in presenting my experiences through my art.

When people feel imprisoned, the tight locks that bind them will be released as soon as they are able to take a step back and look at themselves objectively. When you are suffering with something alone, seeing the wounds others bear and sympathizing with their pain helps relieve narrow-sighted obsessions. In short, by saving others, you will also save yourself.

As someone weak who does not want to be left for dead, I must learn to understand the pain of others that are hurt. I wish to create a society where nobody is left behind.

《修復のモニュメント「卒業アルバム」》
2019年｜インスタレーション｜ビデオ、コンクリートに金継ぎ、原稿用紙
共同制作：T氏

Monument of Recovery "Graduation Album"
2019 | Installation | Video, Kintsugi to concrete, Manuscript paper
Collaborative production: Mr. T

Tさんはいじめの被害経験をきっかけにその後10年以上に渡ってひきこもり生活を続けた。私が対話の中で感じたのは、Tさんは怒りの表明や抵抗をあまり得意とはしない優しい性格だったのだと思う。しかし永いひきこもりの時間の中で、ある時Tさんは、いじめの加害者たちの写真も掲載された豪華で分厚い卒業アルバムを破壊した。その時のアルバムはもうこの世には無い。おそらくその時の行為の意味をTさん自身、まだ迷いの中で受け止め切れてはいないように見えた。

ひきこもりというテーマについて当事者環境に身を浸して取材や交流を続けていた私は、様々な当事者会でなぜかよく顔を合わせる男性が居た。物腰が柔らかくいつも丁寧な言葉遣いの人だった。それが後に交流をすることになったTさん。ある雑誌媒体で、Tさんがこの卒業アルバムの破壊の経験について手記を書いているのを私が読んだことをきっかけに共同制作の提案をした。文章は言語化しづらい感情をどうにか客観的に言葉にし始めているという印象を持った。

それから、Tさんに詳しく記憶の中の卒業アルバムについて情報をもらい、私がそれをもとにコンクリートで再現をし、その後一旦二人でハンマーで叩き壊したのち、「金継ぎ」修復を進めた。

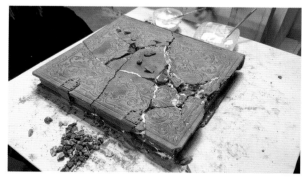

Tさんはロックミュージックが好きなのだけれど、ロックはまさにカウンターカルチャーだ。怒りや抵抗の表明は必ずしも暴力的でいけないものとも限らない。そして私はアートの表現自体にもそうした側面があることを知っている。

Tさんの提案によって、壊れた破片を完全に修復し直すということはせず、部分的にかけらをそのまま残すことにした。金継ぎは負の経験を転換させ、ポジティブな価値にすることと言えるが、Tさんの現実は必ずしも経験の全てを価値更新出来たわけでもない。そしてそれが必要とも限らない。もしかしたら、とらわれをとらわれのまま、許せないものを許さないまま残していく部分もあっていいのかもしれない。

これからも再構築を続けるTさん自身の様子を表すこれらの破片も展示台の上に一緒に置いた。

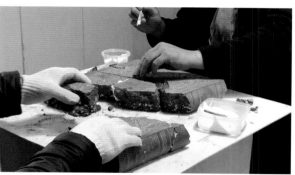

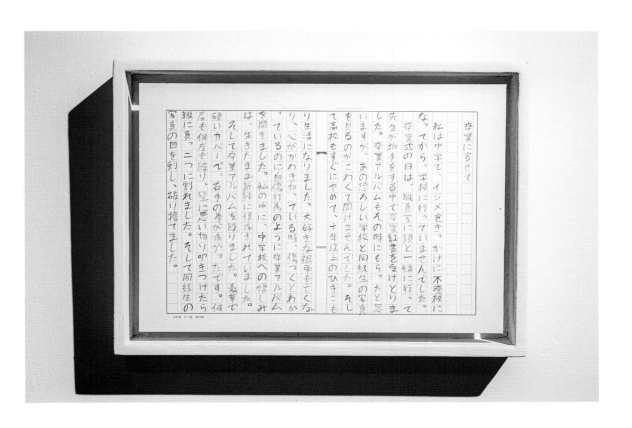

「卒業に寄せて」

私は中学生の時に受けたいじめをきっかけに不登校になってから、学校に行っていませんでした。

卒業式の日は、職員室に親と一緒に行って先生が拍手をする中で卒業証書を受け取りました。卒業アルバムをその時にもらったと思いますが、あの恐ろしい学校と同級生の写真を見るのがこわくて開けませんでした。そして高校もすぐにやめて、十年以上のひきこもり生活になりました。大好きな祖母も亡くなり、心がかわききっている時、傷つくとわかっているのに自傷行為のように卒業アルバムを開きました。私の中に、中学校への憎しみは、生きたまま新鮮に保存されていました。そして卒業アルバムを殴りました。豪華で硬いカバーで、右手の拳が痛かったです。何度も何度も殴り、壁に思い切り叩きつけたら縦に真っ二つに割れました。そして同級生の写真の目を刺し、破り捨てました。

53

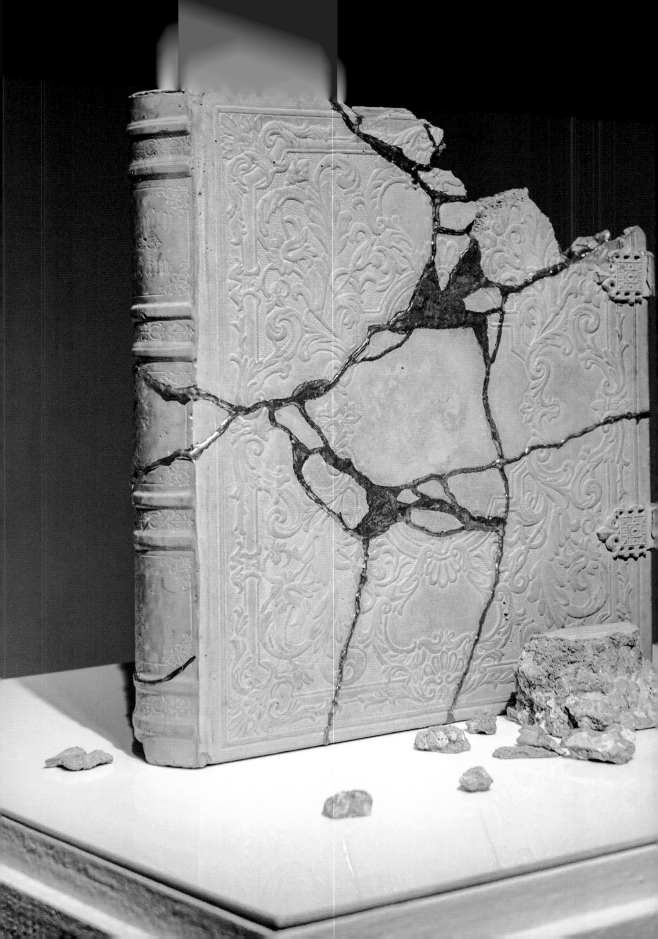

《修復のモニュメント「卒業アルバム」》
2019年｜共同制作：T 氏

Monument of Recovery "Graduation Album"
2019 | Collaborative production: Mr. T

《修復のモニュメント「脳と心臓」》
2019年｜インスタレーション｜ビデオ、コンクリート
に金継ぎ、シャウカステンなど
共同制作：ゆりな

Monument of Recovery "Brain & Heart"
2019 | Installation | Video, Kintsugi to concrete, X
illuminator, etc.
Collaborative production: Yurina

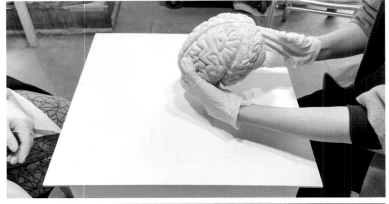

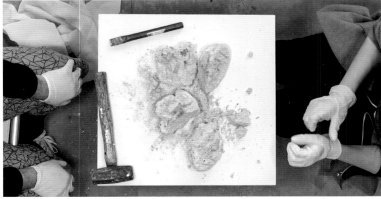

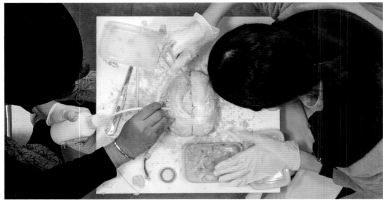

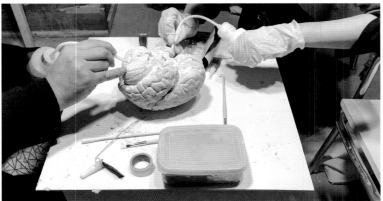

脳は、いじめや心的外傷によって物理的に傷
つくことが、近年判ってきた。前頭前野の萎縮、
聴覚野や扁桃体の変形などが起こる。心が傷
つく度に、脳が射貫かれる感覚、心臓の鼓動
が早くなる感覚があるというゆりなさんは、社
会に向けて自身の痛みの可視化を行う。

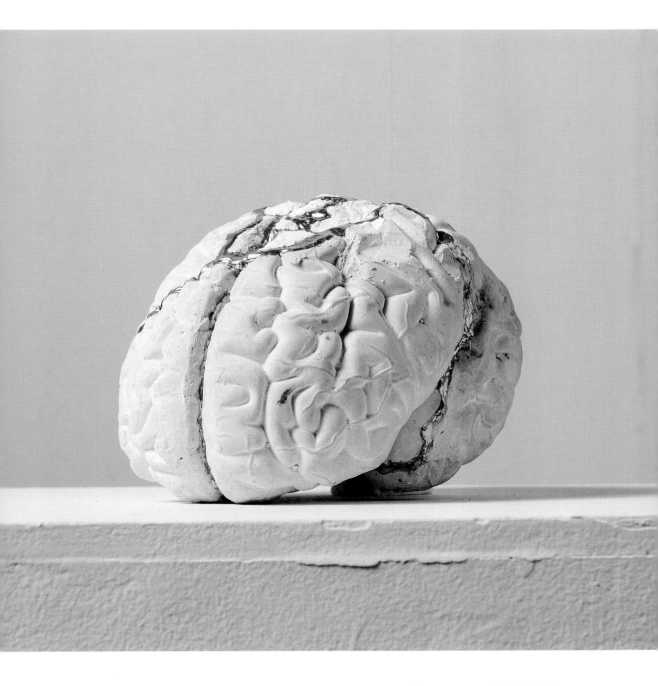

《修復のモニュメント「脳と心臓」》（部分）
2019年｜共同制作：ゆりな

Monument of Recovery "Brain & Heart" (part)
2019 | Collaborative production: Yurina

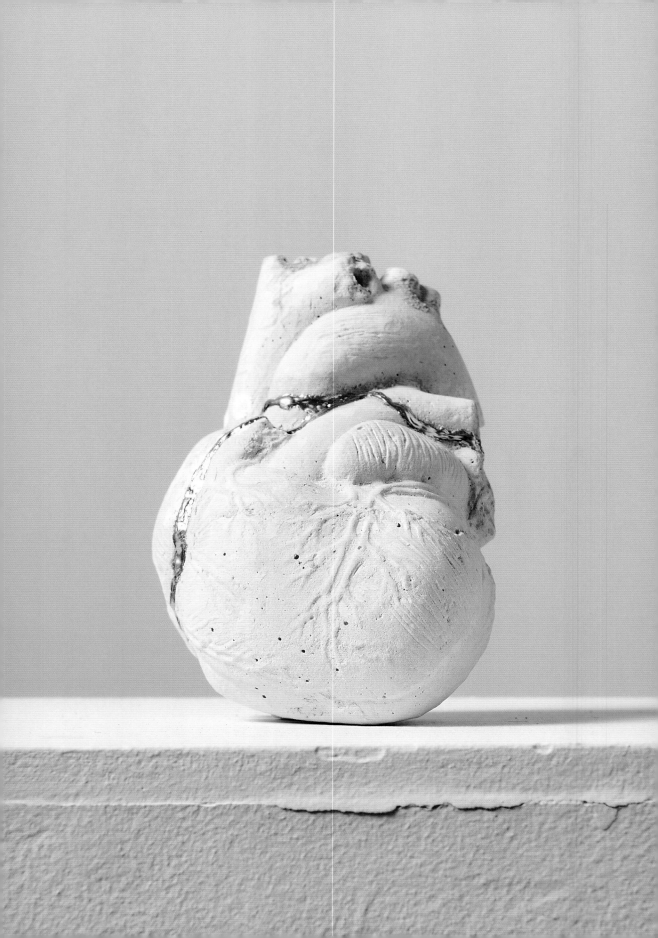

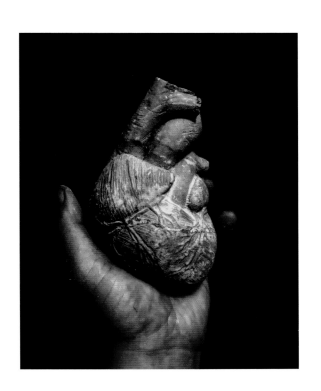

《修復のモニュメント「脳と心臓」》（部分）
2019年｜共同制作：ゆりな

Monument of Recovery "Brain & Heart" (part)
2019 | Collaborative production: Yurina

《修復のモニュメント「病院」》
2019年｜インスタレーション｜ビデオ、コンクリートに金継ぎ、歩行器など
共同制作：S氏

Monument of Recovery "Hospital"
2019 | Installation | Video, Kintsugi to concrete, WALKING AID, etc.
Collaborative production: Ms. S

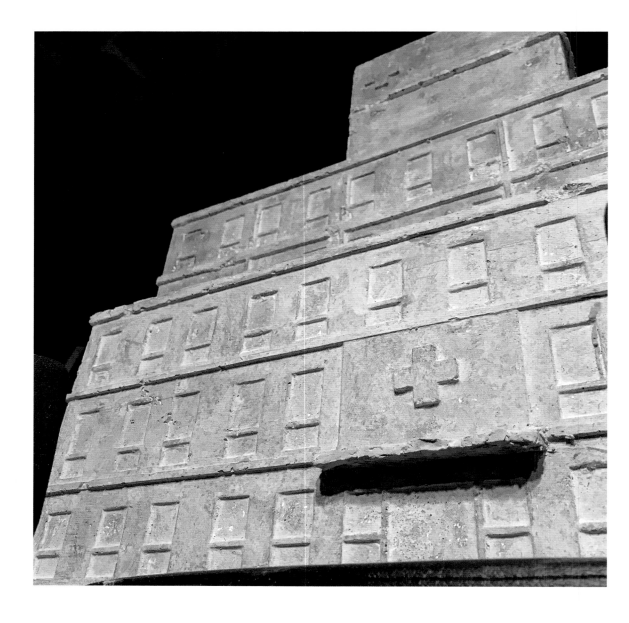

理学療法士を目指す大学に通い、病院内のリハビリテーション室での実習に参加したものの、そこでパワハラを受けたとことをきっかけにひきこもりになったSさん。病院は、ある者にとっては治療や社会復帰の為の場でありながら、また別のある者にとっては能力の競争や権威の象徴、そして社会からの撤退の原因にもなりえていた。

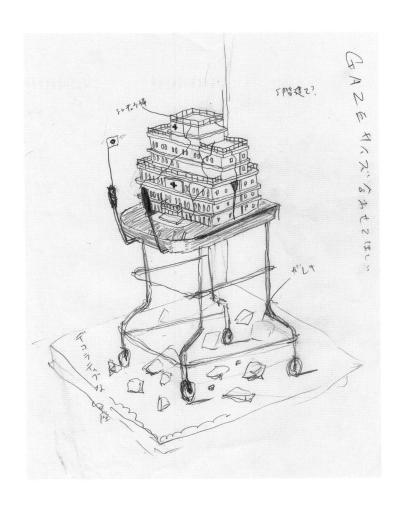

GAZE

5階建て.

デコラック燈

ガレキ

GAZEをタイスかるみたてほし...

デコライテッド

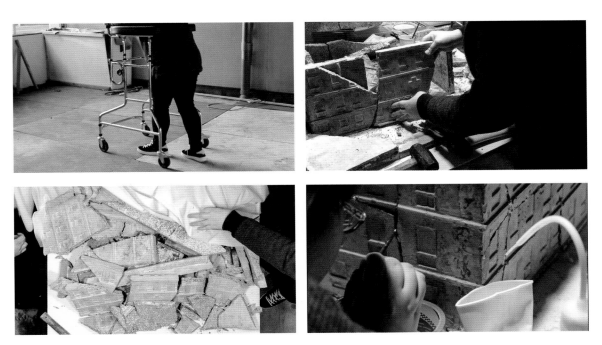

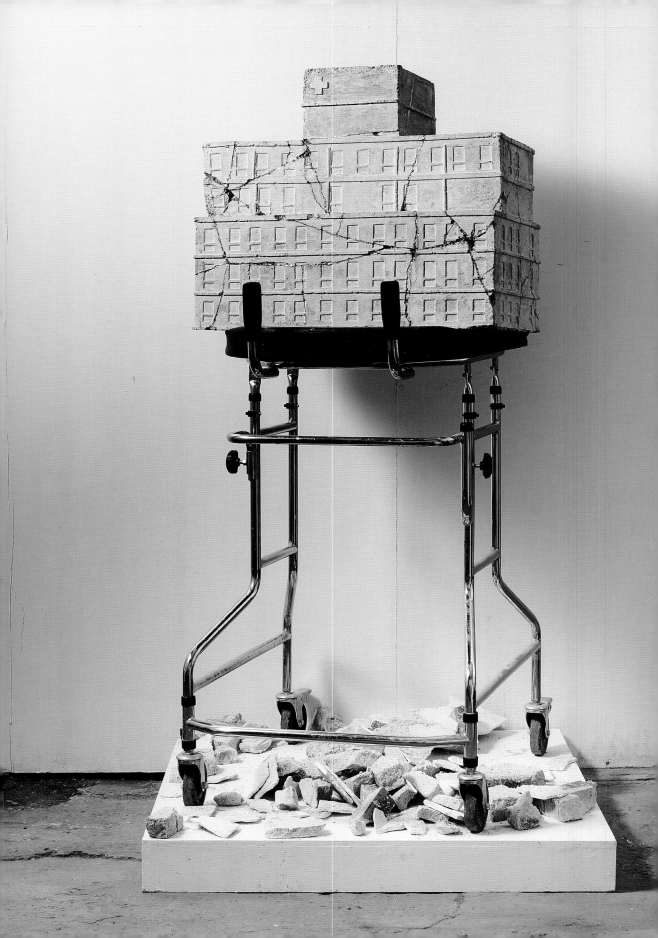

《修復のモニュメント「病院」》
2019年｜共同制作：S氏

Monument of Recovery "Hospital"
2019 | Collaborative production: Ms. S

《修復のモニュメント「01」》
2019年｜インスタレーション｜ビデオ、コンクリート
に金継ぎ、黒板など
共同制作：E氏

Monument of Recovery "01"
2019 | Installation | Video, Kintsugi to concrete,
blackboard, etc. |
Collaborative production: Mr. E

Eさんは I.Q が高く幼少期から知識欲が強かっ
た。同級生の遊びに魅力を感じず、結果、孤
立を知る。東大に入った彼は数学に没頭した。
森羅万象は0と1だけで表せられるのだと。け
れど「01思考」とは有と無で切り分ける極論
的な思考の事でもある。数字と対峙したEさ
んは容易く修復出来ない程01を叩き壊した。

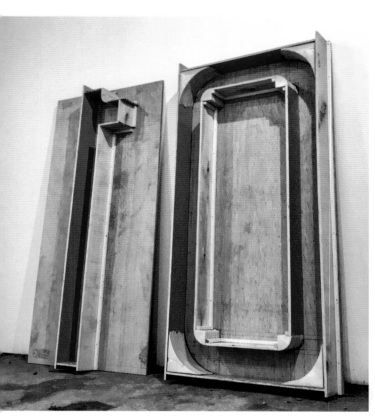

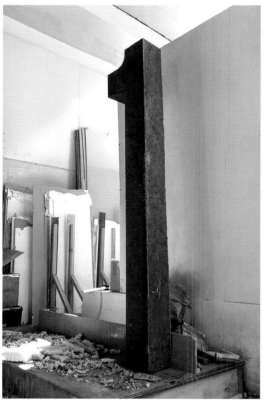

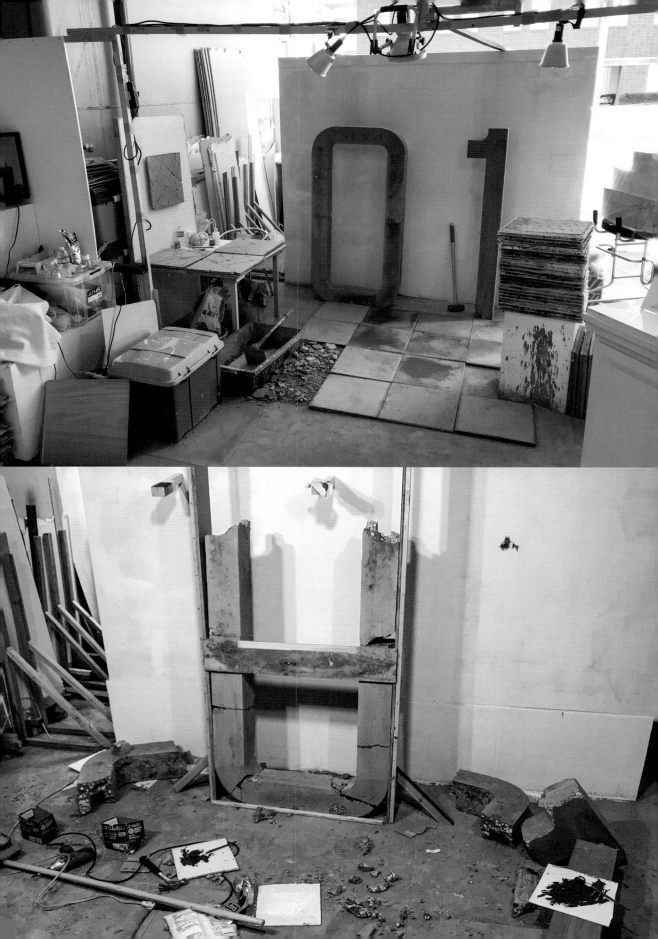

$$1 + \frac{1}{2} + \frac{1}{3} + \cdots + \frac{1}{n} = \sum_{k=1}^{n} \frac{1}{k} = S(n)$$

$$S(80) \simeq \frac{4880}{982}$$

$$\simeq 4.97 \quad \longrightarrow \quad \frac{S(6)}{S(80)} \simeq 0.5 \quad (= 50\%)$$

$$S(6) = \frac{49}{20}$$

$$= 2.45$$

$$\frac{S(25)}{S(80)} \simeq 0.77 \quad (= 77\%)$$

$$S(25) \simeq 3.81 \quad \longrightarrow$$

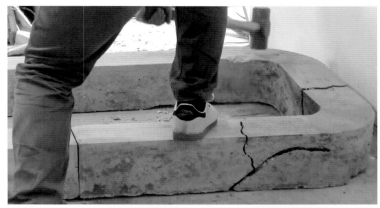

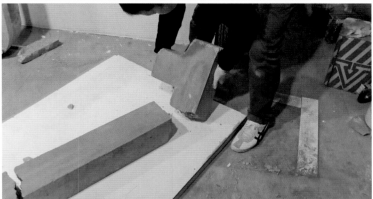

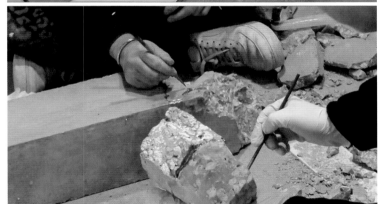

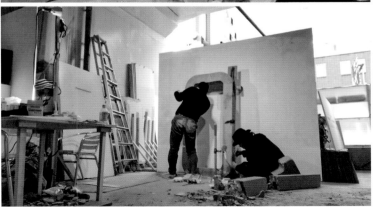

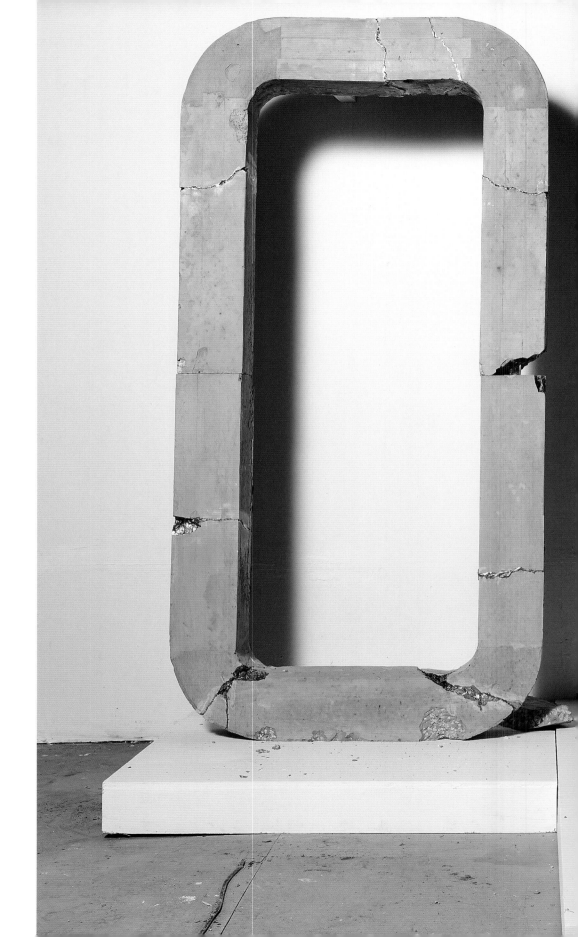

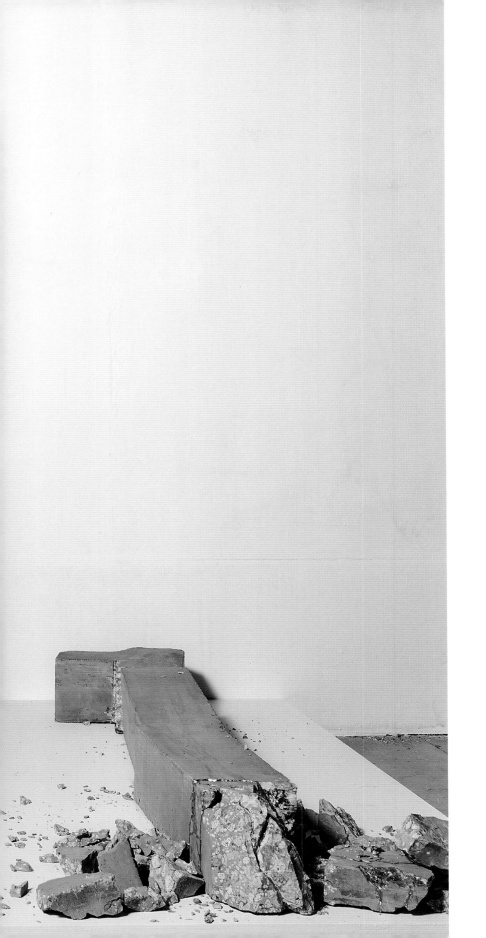

Beyond the Line between Victims and Perpetrators

《被害者と加害者の振り分けを越えて》

会場に敷き詰めたコンクリートタイルは、困窮者支援やケアの名の下であっても自動的に発生し続ける加害性やそれに対する自己批判の必要性について観る者に突き付ける。我々は自己や社会をどの様に再構築できるのだろうか。鑑賞客が壁の絵画作品を鑑賞する時、このタイルを踏み割って歩くことを避けられない。

The concrete tiles in the venue symbolize perpetration and victims; perpetration repeatedly generating in society under the name of social support or care for the social weak in torturous self-condemnation. In what way do we reform ourselves and social realm?
Audience cannot avoid stepping on and breaking these tiles in order to appreciate the paintings on the wall.

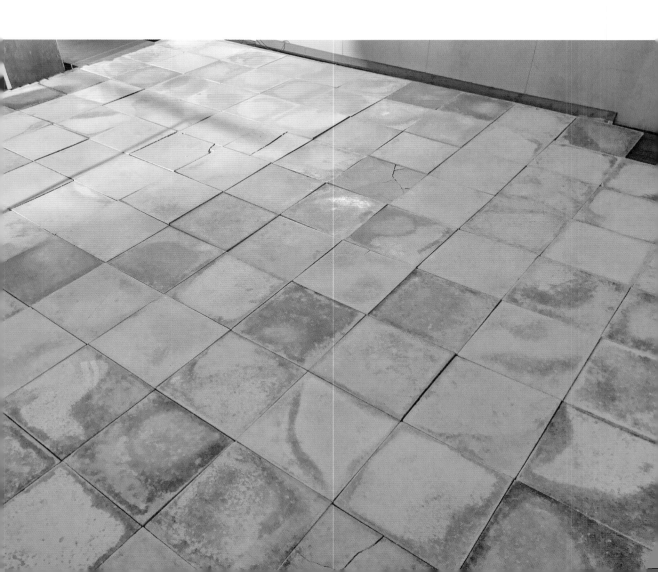

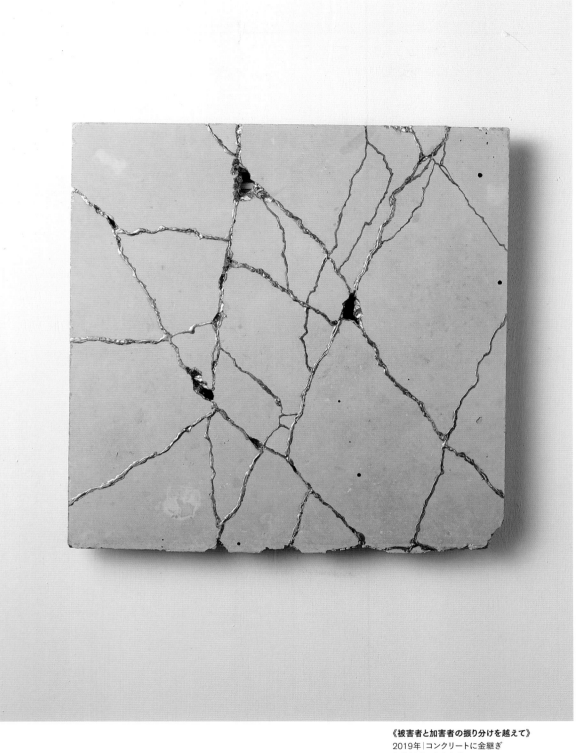

《被害者と加害者の振り分けを越えて》
2019年｜コンクリートに金継ぎ
制作協力：駒木崇宏

Beyond sorting Victims and Perpetrators
2019 | Kintsugi to concrete
Cooperation: Takahiro Komaki

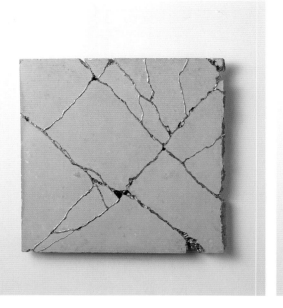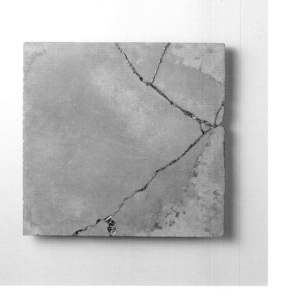

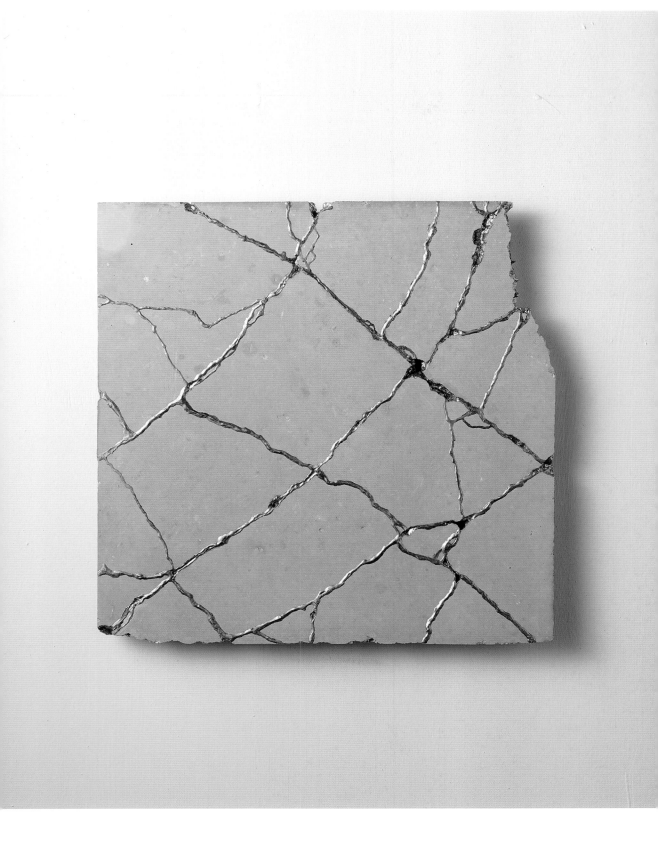

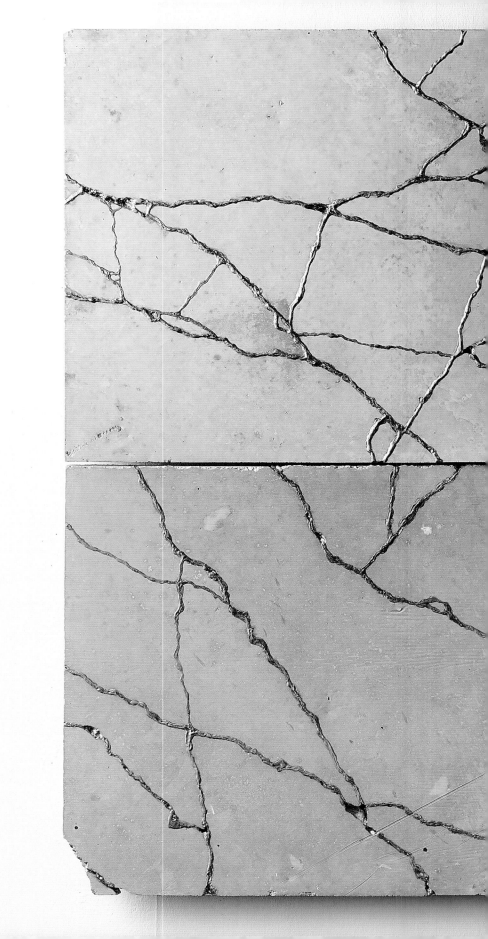

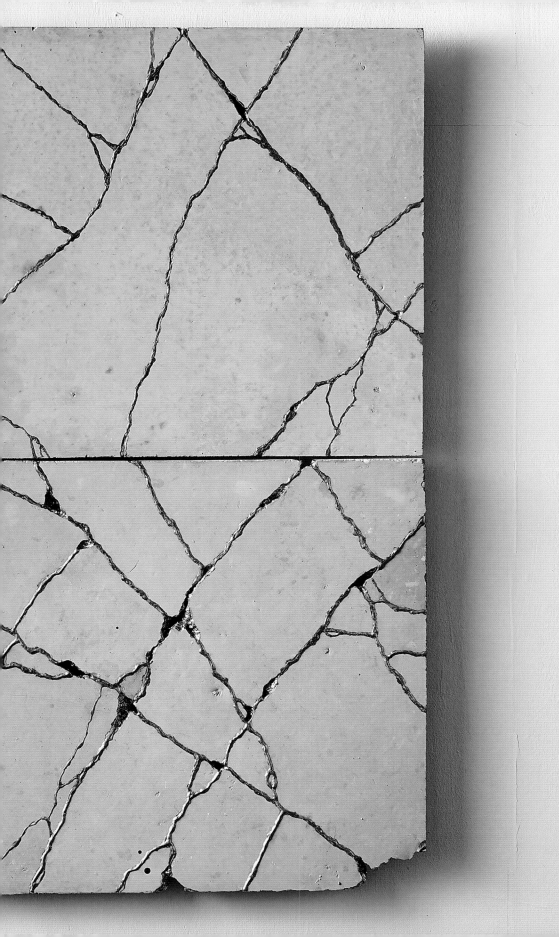

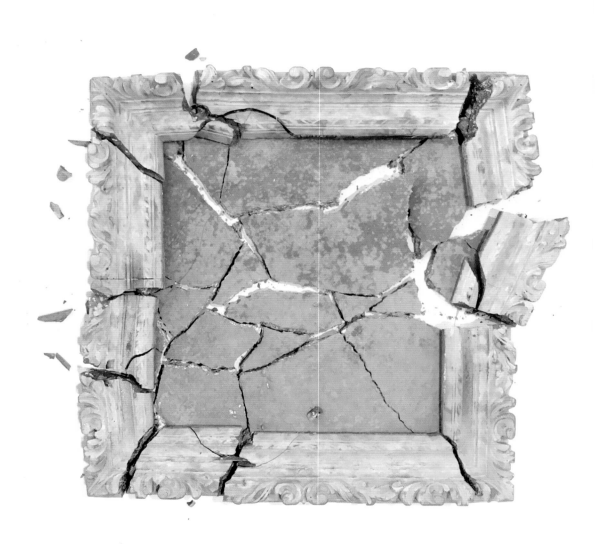

《被害者と加害者の振り分けを越えて》
2020年｜コンクリートに金継ぎ
制作協力：駒木崇宏

Beyond sorting Victims and Perpetrators
2020 | Kintsugi to concrete
Cooperation: Takahiro Komaki

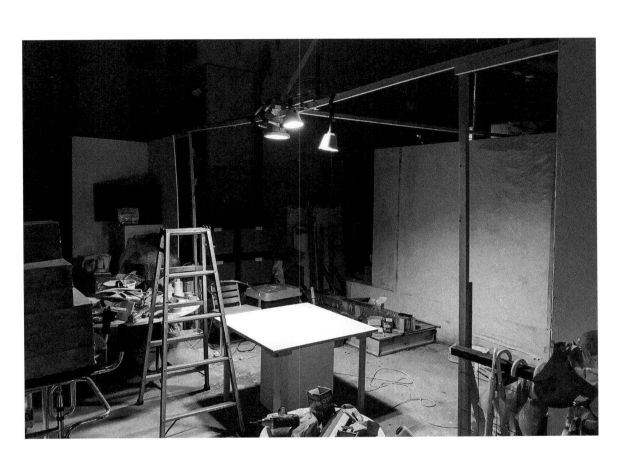

渡辺 篤｜わたなべ あつし

現代美術家。東京藝術大学在学中から、直接的／間接的な経験を
根幹とする、新興宗教・経済格差・ホームレス・アニマルライツ・精
神疾患・セクシュアルマイノリティなどの、社会からタブーや穢れと
して扱われうる要素を持った様々な問題やそれにまつわる状況を批
評的に取り扱ってきた。
近年は、不可視の社会問題でもあり、また自身も元当事者である「ひ
きこもり」の経験を基点に、心の傷を持った者たちと協働するインター
ネットを介したプロジェクトを多数実施。そこでは、当事者性と他者性、
共感の可能性と不可能性、社会包摂の在り方についてなど、社会
／文化／福祉／心理のテーマにも及ぶ取り組みを行う。
社会問題に対してアートが物理的・精神的に介入し、解決に向け
た直接的な作用を及ぼす可能性を追求している。

主な個展及びプロジェクト展は「修復のモニュメント」（BankART SILK、神奈川、2020年）、
「ATSUSHI WATANABE」（Daiwa Anglo-Japanese Foundation、ロンドン、イギリス、2019年）、
「アイムヒア プロジェクト写真集出版記念展"まなざしについて"」（高架下スタジオSite-Aギャラリー、
神奈川、2019）、「わたしの傷／あなたの傷」（六本木ヒルズ A/Dギャラリー、東京、2014）など。
主なグループ展は「2020 MMCA Asia Project 'Looking for another family'」（National Museum
of Modern and Contemporary Art, Korea、ソウル、韓国、2020年）、「ARTEFACT 2020 :
ALONE TOGETHER」（STUK、ルーヴェン、ベルギー、2020年）、「雨ニモマケズ（singing in
the rain）」（BankART Station ／ R16スタジオ、神奈川、2019年）など。
2018・2019年には「クリエイティブ・インクルージョン活動助成」および2016年・2017「若手芸術家育
成助成」アーツコミッション・ヨコハマ）に採択。2016年「ARTISTS' GUILD」加入。

作品発表以外では、当事者経験や表現者としての視点を活かし、福祉番組「ブレイクスルー」（NHK
Eテレ、2016年）、「ハートネットTV」（NHK Eテレ、2018-2019年）などのテレビ出演や、雑誌・
新聞・ウェブへの執筆多数。アートのジャンル内外でレクチャーも行う。

・「渡辺 篤」ウェブサイト: https://www.atsushi-watanabe.jp/
・「アイムヒア プロジェクト」ウェブサイト: https://www.iamhere-project.org/

2013年　ひきこもり生活から美術家として復帰、以後勢力的に活動を続ける
2010年　7ヶ月半自室を出ずに寝たきりの生活を送る（2011年まで）
2009年　東京藝術大学大学院 美術研究科 絵画専攻（油画）修了
2007年　東京藝術大学 美術学部 絵画科油画専攻 卒業
1978年　神奈川県 横浜市 生まれ

Atsushi Watanabe

Contemporary artist.
Since Graduating from Tokyo University of the Arts, Atsushi Watanabe has been presenting socially critical artworks based on his and other peoples experiences with emotional scars and mind traps. The subject matter varies from new religions, economic disparity, homelessness, animal rights, sexual minorities, *hikikomori* to mental illnesses — things which are often viewed negatively and as taboo by society.

In recent years, he has worked on numerous projects that used the internet to get the cooperation of emotionally scarred people, in order to investigate hidden social issues, as well as his own experiences as a "hikikomori." In doing so, his work tackles the possibility and impossibility of empathy between insiders and outsiders, and of the nature of social inclusion, as well as extending to themes of society, culture, welfare and psychology.

Watanabe's work seeks the possibility of an art that acts directly to make mental interventions in social problems and thereby solve them.

Selected solo and project exhibitions: *Monument of recovery* (BankART SILK, Kanagawa, 2020), *ATSUSHI WATANABE* (Daiwa Anglo-Japanese Foundation, London, England, 2019), *I'm here project Photobook publication commemoration exhibition "Gaze"* (Site-A Gallery Beneath the Railways, Kanagawa, 2019), *My wounds / Your wounds* (Roppongi Hills A/D Gallery, Tokyo, 2017).

Selected Group exhibitions: *2020 MMCA Asia Project 'Looking for another family'*, (National Museum of Modern and Contemporary Art, Seoul, Korea, 2020), *ARTEFACT 2020 : ALONE TOGETHER* (STUK, Leuven, Belgium, 2020), *Ame ni mo makezu: singing in the rain* (BankART Station / R16studio, Kanagawa, 2019).

In 2018/2019 Watanabe was selected for the "Arts Commission Yokohama Creative Inclusion Grant." In 2016/2017 he was selected for the "Arts Commission Yokohama Creative Children Fellowship." In 2016, he joined ARTIST'S GUILD.

In addition to putting out artistic works, Watanabe has also appeared in television programs such as the social welfare program "Breakthrough" (NHK E-Tele, 2016), and "Heart Net TV" (NHK E-Tele, 2018-2019), and contributed writing to magazines, newspapers, and online publications, for the perspective of someone who has experienced social problems, and as a cultural commentator. He also lectures on topics both within art and on other topics.

・Atsushi Watanabe website : https://www.atsushi-watanabe.jp/
・*I'm here project* website : https://www.iamhere-project.org/

2013 Watanabe recovered from living as a hikikomori to return to his career as an artist, which he has since pursued energetically.
2010 He spent 7months never leaving his room, doing hardly anything other than sleeping (until 2011).
2009 Finished Oil Painting Major, the Graduate School of Fine Arts, Graduate School of Tokyo University of the Arts.
2007 Graduated Painting, Fine Arts, Tokyo University of the Arts.
1978 Born in Yokohama, Kanagawa, Japan.

謝辞 / Acknowledgments

2016〜2019年度、アーツコミッション・ヨコハマによる作品制作の多大なるご支援を戴きました。

Watanabe has been supported by Arts Commission Yokohama for his works from FY2016 to FY2019.

写真撮影：高橋大地 [P52]、ひきこもりの人たち [P19-23, 24（上）]、井上圭佑 [P7-9, 16, 17, 26, 27, 29（上）, 30, 31, 37, 39-45, 53, 55, 57, 58, 62, 68, 69, 72（上段）, 73, 74, 75, 78]、Michiyo Koga [P28]、中川達彦 [P25, 46-47]
写真撮影補助：Ryoko Inoue [P37, 39-45, 57, 58, 62, 68, 69, 71, 72（上段）, 73, 74, 75]
フォトディレクション／フォトレタッチ：井上圭佑 [P19-23, 24（上）]
映像撮影：井上圭佑 [P11]
映像撮影補助：中村晃太 [P67]、檜村さくら [P61]
映像編集：井上圭佑 [P51]、檜村さくら [P56, 61, 67]

Photography: Daichi Takahashi [P52], Hikikomori people [P19-23, 24 (above)], Keisuke Inoue [P7-9, 16, 17, 26, 27, 29 (above), 30, 31, 37, 39-45, 53, 55, 57, 58, 62, 68, 69, 72(upper), 73, 74, 75, 78], Michiyo Koga [P28], Tatsuhiko Nakagawa[p25, 46-47]
Photography assistance: Ryoko Inoue [P37, 39-45, 57, 58, 62, 68, 69, 71, 72 (upper), 73, 74, 75]
Photo Direction / Photo Retouching: Keisuke Inoue [P19-23, 24 (top)]
Video shooting: Keisuke Inoue [P11]
Video shooting assistant: Kota Nakamura [P67], Sakura Himura [P61]
Video editing: Keisuke Inoue [P51], Sakura Himura [P56, 61, 67]

I'M HERE
ATSUSHI WATANABE

2020年2月21日初版発行

First edition, published 21 February 2020

編　集	BankART1929	Edited by	BankART1929
テキスト	福住 廉	Text by	Ren Fukuzumi
	渡辺 篤		Atsushi Watanabe
デザイン	北風総貴	Designed by	Nobutaka Kitakaze
翻　訳	ジョン・バレット [P4-5, 34-35]	Translated by	John Barrett [P4-5, 34-35]
	山田よしえ		Yoshie Yamada
	水野 響（ATC）[P6, 10, 36, 51]		Hibiki Mizuno (ATC) [P6, 10, 36, 51]
翻訳校正	山田よしえ [P4-5, 34-35]	Revised by	Yoshie Yamada [P4-5, 34-35]
	Sam Stocker [P18, 26]		Sam Stocker [P18, 26]
翻訳校正補佐	新江千代 [P18, 26]	Translation Assistance	Chiyo Arae [P18, 26]
協　力	川村格夫	Cooperation by	Tadao Kawamura,
	プロジェクト「あなたの傷を教えて下さい。」		"Tell me your emotional scars"
	匿名投稿者の方々		proiject Anonymous contributors
発　行	BankART1929	Published by	BankART1929
	〒231- 0012		#410 Taisei Bld. 3-61
	横浜市中区相生町3-61泰生ビル410		Aioi-cho, Naka-ku,
	TEL: 045-663-2812		Yokohama, Kanagawa 231-0012
	info@bankart1929.com		Tel. 045-663-2812
	http://www.bankart1929.com		info@bankart1929.com
			http://www.bankart1929.com
印刷製本	株式会社シナノ	Printed by	Shinano Co, Ltd in Japan